# IMAGES
## of America

# ARTESIA
## 1875–1975

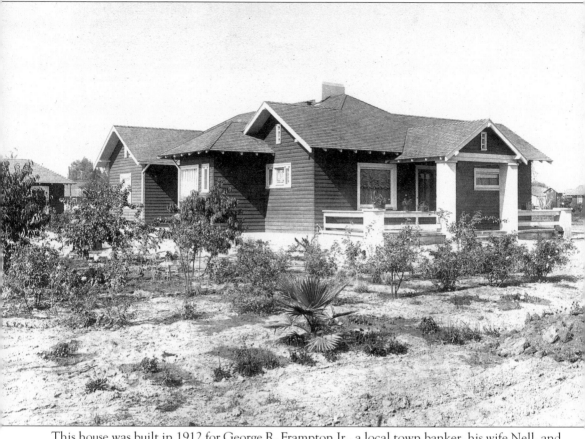

This house was built in 1912 for George R. Frampton Jr., a local town banker, his wife Nell, and his son Howard. Mr. Frampton sold this house to Mr. and Mrs. Albert O. Little in 1941. It is one of the oldest homes still standing in Artesia. Al and Veronica's daughter, son-in-law, and granddaughter continue to live in this house today.

*Cover Photo*: "School days, school days." Students stand in front of the Artesia Grammar School in the early 1900s.

IMAGES
of America

# ARTESIA
## 1875–1975

Compiled by Albert O. Little
Edited by Veronica L. Bloomfield and
Veronica E. Bloomfield

ARCADIA

Published by Arcadia Publishing,
an imprint of Tempus Publishing, Inc.
2 Cumberland Street
Charleston, SC 29401

Printed in Great Britain.

Library of Congress Catalog Card Number: 00-100166

For all general information contact Arcadia Publishing at:
Telephone 843-853-2070
Fax 843-853-0044
E-Mail sales@arcadiapublishing.com

For customer service and orders:
Toll-Free 1-888-313-2665

Visit us on the internet at http://www.arcadiaimages.com

Albert O. Little came to Artesia in 1926. In 1939, he opened the "A. Little Auto Parts" machine and auto repair shop, located on Pioneer Boulevard, which he later sold in 1954. He served as president of the Artesia Chamber of Commerce in 1937, 1938, and 1947. In 1956, he became the manager of the Artesia Chamber of Commerce, maintaining that position for ten years. He served on the committee that brought about the city's incorporation in 1959. He also served as the city's Community Development Officer and Photographer from 1969 until his death in 1987. Throughout the years, he became affectionately known as "Mr. Artesia."

# CONTENTS

Albert O. Little celebrated his 80th birthday on December 8, 1979. His granddaughter, Veronica Elizabeth, turned seven years old one week later. Veronica learned to love Artesia by accompanying her grandfather to community events, by helping him take and develop pictures, and by listening to the stories her grandfather used to tell about the city's history and the pride of its residents. The one phrase Veronica remembers her grandfather saying the most is, "Of all the places I've been, I like Artesia best."

# PREFACE

In 1975, my grandfather edited a publication called *The Artesians: How It Began One Hundred Years Ago.* Four years later, he edited a second volume titled *The Artesians: Twenty Years of Incorporation.* For the purposes of these two publications, he gathered a great many photographs and considerable narrative material. It was his hope that one day he would be able to share his historical knowledge of this area and his love for the city with the rest of the community in a pictorial history. Sadly, while in the process of putting this text together, he passed away. There is nothing that would have made him more proud than to have seen this project be completed and made available to the residents of Artesia.

For the past several years, my parents and I have tried to honor his legacy of love and dedication by going through old pictures, talking about the faces and places that defined Artesia, and compiling these materials into a "history."

History itself is a dynamic process that includes many people and experiences. This book is not the complete, definitive history of Artesia. It is my grandfather's version, his rendition of how Artesia came to be. It would have been impossible for him or for us to represent every person's memories and recollections of this city as it has developed. Rather, what we have hoped to do is create a kind of scrapbook. The pictures and words in this text come from my grandfather's archives and the many friends and associates he had in this town over the years.

We hope that each of you will find a piece of yourself in the memories, stories, and pictures of this sweet, small town. It is our hope that each of you will be inspired to add your own commentary to these pictures as you see them; to talk with your friends and family about "the good old days;" and even to get out your own family collection of pictures to share with your loved ones.

More than anything, we hope that this book will inspire you to celebrate your own history as we all CELEBRATE ARTESIA!

Veronica Elizabeth Bloomfield
December 8, 1999

# Introduction

The area now known as California was occupied for hundreds of years by Native Americans. An estimated 300 different groups lived in California, each of which occupied its own region, spoke its own language, and had its own customs.

The Native Americans of California were hunter-gatherers who employed fishing techniques. They gathered food from the sea and nearby foothills. They hunted small animals and larger game such as antelope and deer. They lived in earth-covered plank houses. Men wore a skin folded around the hips, women a short skirt with an apron in front. The Native Americans of California participated in trading activities where currency was represented in the form of shells.

The religion of the Californians coincides with indigenous beliefs around the world. Rites of passage for birth, death, marriage, and puberty were observed by all. The shaman was the religious leader of the group. Shamans would perform ceremonies to heal the sick and to celebrate religious observances. California shamans were associated with the grizzly bear for its power to destroy enemies and return to life.

On September 28, 1542, Juan Rodriguez Cabrillo, a Portuguese explorer, arrived in California from the west coast of Mexico. Another explorer, Sebastian Vizcaino, returned to California after reading Cabrillo's notes in Mexico. On November 12, 1602, Vizcaino landed in San Diego and celebrated High Mass. The land was claimed for Spain. Spanish settlers came to California in 1769. Juniperro Serra, a Spanish friar, was one of these settlers who hoped to convert the natives. By 1770, two missions had been built—one in San Diego and one in Carmel.

The mission system in California was the most effective way to impose Spanish culture on the native people. The missions attempted to Christianize the natives, teaching them Spanish and the "civilized" customs of Europe. The complete integration of the native population never took place. Instead of becoming true members of society, the Native Americans of California became a laboring class that was exploited as the colony grew. They had to obey and participate in religious rites, as well as the daily mission activities and subsequent abuse. Many "Indians" also died of European diseases such as small pox. Intermarriage between the Spanish and Native Americans created an entirely new population.

In 1781, the pueblo of Los Angeles was established. In 1784, Governor Pedro Fages granted Manuel Nieto use of the mission lands to herd cattle and horses. In 1804, Manuel Nieto, the richest man in California, died. In 1821, the Mexican people established the Republic of Mexico. During this time, in the 1820s, more European and American settlers came to California to make a living.

The first overland wagons arrived in California in 1826, and Abel Stearns came to Los Angeles in 1829. On August 9, 1833, the Mexican government declared the secularization of mission lands. One year later, in 1834, the heirs of Manuel Nieto petitioned Jose Figueroa for the title to the land grant known as Rancho Los Coyotes. The governor granted their petition and distributed the land into five parcels: Los Coyotes, Las Bolsas, Los Alamitos, Los Cerritos, and Santa Gertrudes.

In 1840, Juan Jose Nieto sold Rancho Los Coyotes to Andreas Pico of California. Six years later, on July 7, 1846, California was annexed to the United States. On May 30, 1848, the war with Mexico came to an end with the signing of the Treaty of Guadalupe Hidalgo. California became a member of the United States of America on September 9, 1849.

The life of the ranchos changed greatly during the years from 1862 to 1864. The great drought of those years killed cattle by the thousands, which practically ruined the large landowners. In 1868, Abel Stearns, like many other landowners, sold his rancho to be divided into farmland. In 1869, Daniel Gridley purchased 1,600 acres of land from Abel Stearns. By May of 1873, many farm families were living in the Artesia area.

# One

# SCHOOLS, WELLS, AND FARMS

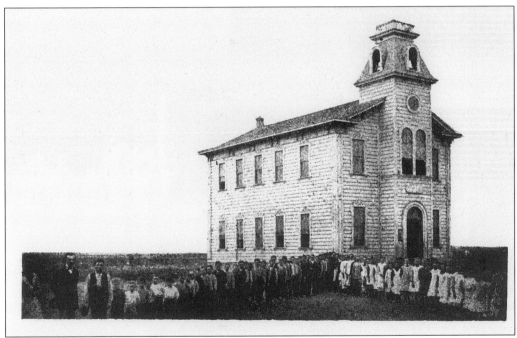

The village of Artesia formally became a community when the Artesia School District was established on May 3, 1875. The Artesia Land Company set aside 5 acres of land at the southwest corner of Main Street and Orange Avenue (Pioneer and 183$^{rd}$ Street) for a school to be built. The first schoolhouse was located at what is now the corner of 183$^{rd}$ Street and Alburtis. The schoolhouse was a rustic, timbered two-story building with a classroom on each floor. At its opening, 44 students were enrolled. The building was heated by a wood-burning stove, and water came from an Artesian well drilled by Nathaniel D. Robinson, school trustee. (Photo courtesy of Hattie Hadewig.)

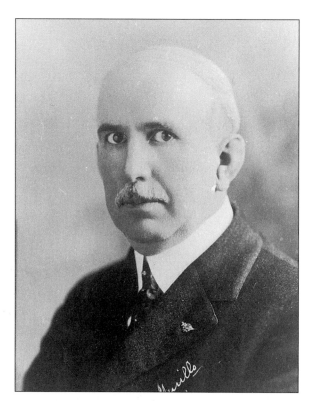

George R. Frampton was the first graduate of the Artesia Grammar School in 1890. He went on to become one of the town's early leaders. A member of one of Artesia's most notable families, George was second president of the first bank, Artesia Citizens Association president, Masonic Lodge Worshipful Master, second Postmaster, as well as an elementary and high school board member.

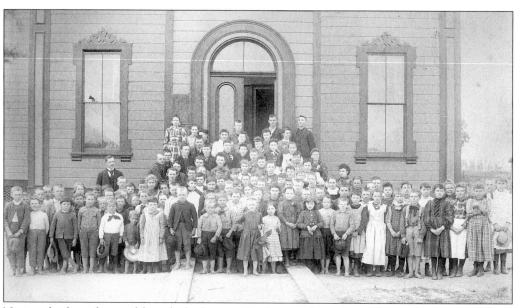

Notice the bare feet and board planks, one for boys and one for girls, at the Artesia School House, *c.* 1892. (Photo courtesy of Hattie Hadewig.)

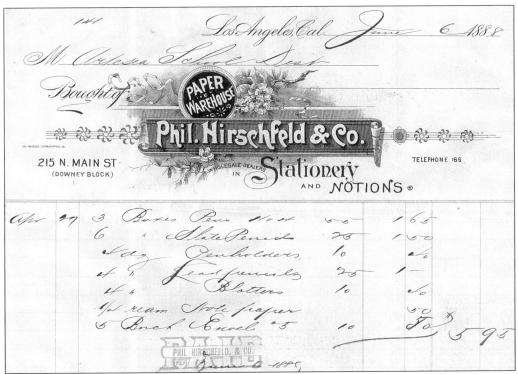

On June 6, 1888, the Artesia School District purchased the following from Phil. Hirschfeld & Company: three boxes of pens, six boxes of slate pencils, four dozen pen holders, four dozen lead pencils, four blotters, one-fourth ream note paper, and five envelopes. The entire list cost $5.95.

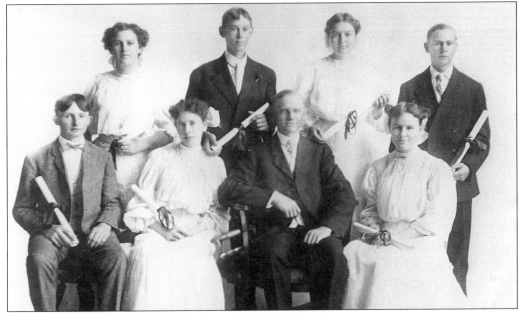

The seven members of the graduating class of 1906 are pictured here with Principal White: (back row) Emma Gaines, Dick Brown, Alpha Gann, and Herbert Decker; (front row) Paul Mitchel, Maggie Hurley, Mr. White, and Eunice Smith.

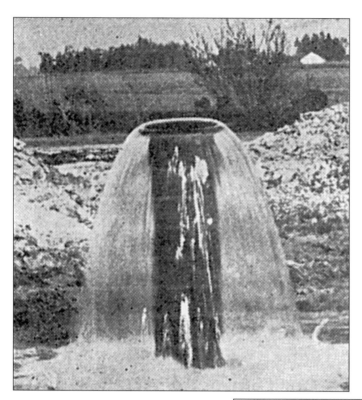

Artesia received its name from the many naturally flowing artesian wells in the area. An artesian well is one drilled through impermeable strata to reach water capable of rising to the surface by internal hydrostatic pressure. The typical early artesian well flowed continually and was capped with a bolted-down metal plate.

"Spot Borden," son of Walter and Nora Borden who owned the Artesia Well Drilling and Machine Shop, is pictured here next to a typical artesian well. Almost every farm in the area had such a well. As the community developed and more artesian wells were drilled, the water level receded, and pumping the water became necessary. In 1903, Clarence Dougherty, a farmer about 1 mile south of Artesia, installed the first gas centrifugal pump.

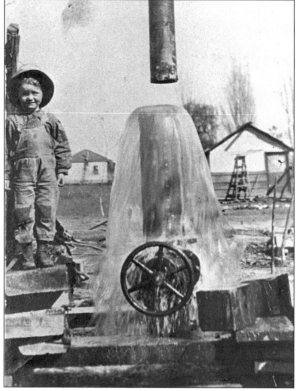

In 1928, the Southern California Water Company purchased the Artesia Water Company for $17,000.

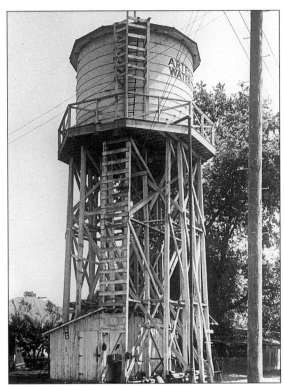

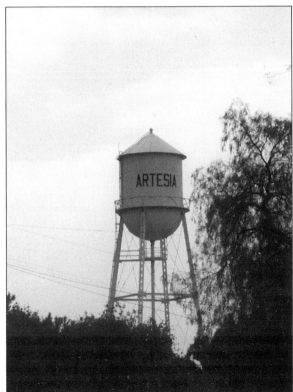

The modern day Artesia water tower, located on the corner of Clarkdale and 183$^{rd}$ Streets, has been a local landmark for many years. The well was originally drilled in 1910.

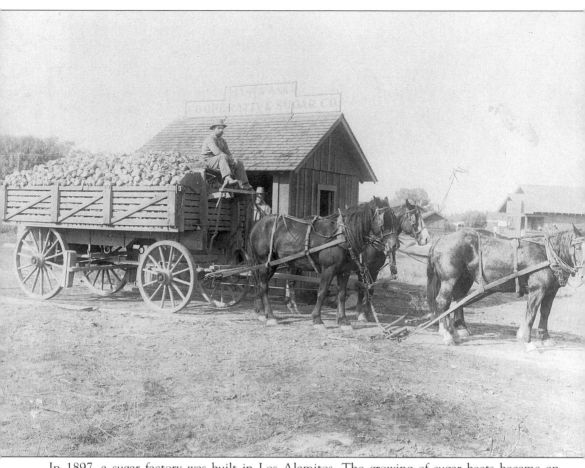

In 1897, a sugar factory was built in Los Alamitos. The growing of sugar beets became an important industry. By 1909, some 900,000 tons of beets had been processed at this factory. Eventually, the sugar factory closed, and poultry raising, truck farming, and dairying again became popular. This 1907 picture shows the first load of sugar beets going from Mr. Walter Frampton's farm to the Santa Ana Cooperative Sugar Company.

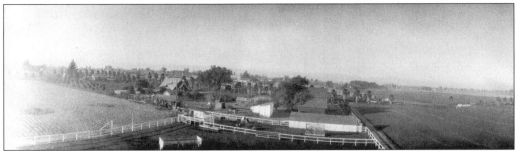

The Frampton farm covered a vast area east and south of the Pioneer and South Street intersection. It was a most impressive development run by Walter and Douglas Frampton. The Holstein dairy herd was reported to be one of the finest in the country. In addition to dairying and raising poultry, an abundance of water encouraged the growing of cauliflower, corn, potatoes, cabbage, peppers, tomatoes, and strawberries. Nurseries grew ferns and flowers. In addition to farming, the Framptons were involved in vineyards, wine making, dairying, well drilling, banking, retailing, and numerous other commercial enterprises.

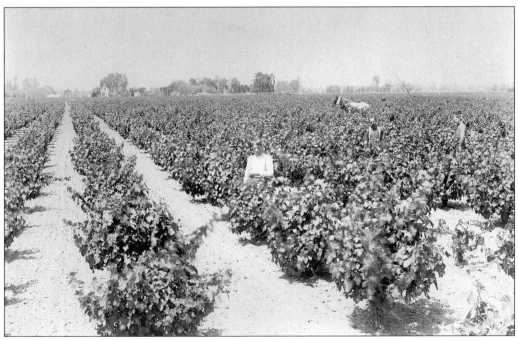

The growing of grapes became an important factor in the agricultural development of the area. In 1885, there were enough vineyards in Artesia to sell grapes to wineries in Downey and Anaheim. The Framptons and O.J. Thompson Sr. operated a winery northeast of the intersection of Pioneer and Artesia Boulevards. The Artesia Winery Company facility was located near the southeast corner of Artesia and Norwalk Boulevards. The above photo is of the O.J. Thompson / George Frampton Sr. Winery at the northeast corner of Artesia and Pioneer Boulevards. (Photo courtesy of Howard Frampton.)

15

This proud chicken surveys one day's collection of eggs from local farmers, headed for delivery at the Frampton Store in 1894.

# Two
# COMMUNITY FIRSTS

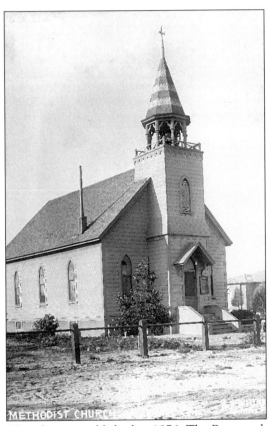

METHODIST CHURCH

The Artesia Methodist Church was established in 1876. The Reverend A.J. Van Anda was the first minister. In 1880, property was purchased at the corner of Pioneer and 183$^{rd}$ Street. The first church was a one-room building, and Sunday school classes gathered in different pews in this room. Later, wires were strung across the church, and curtains were used to separate the classes. There were hitching posts available, as nearly everyone came by horse and buggy. The church bell was installed in 1894.

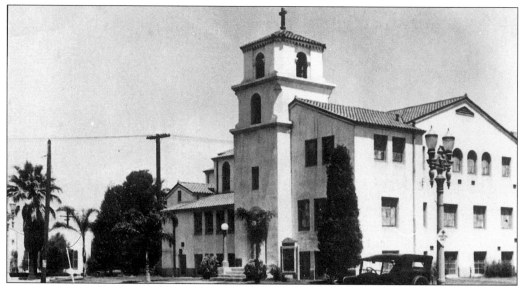

The new Methodist church was built in 1923, at which time the bell from the old church was installed as well. As a consequence of the March 10, 1933 earthquake, Pioneer School was badly damaged. The church housed seven classes from March until the end of the school term. During the 1952 floods, the church was used as a Red Cross evacuation center. An educational wing was added to the church in 1961. In 1968, the name was changed to Artesia-Cerritos United Methodist Church, and in 1971, the congregation moved into the former Artesia Reformed Church at 18523 South Arline Avenue, where it has remained since. (Photo courtesy of Dora Bell.)

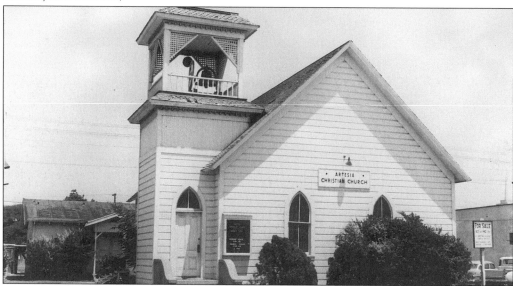

At an 1881 camp meeting, the first roll of Christian Churches was called, and the Artesia church was listed as having 36 members. This group met in the Deering Barn, located southwest of 183rd Street and Pioneer. They also met in private homes and, on occasion, in the schoolhouse. Baptisms took place in the reservoirs close to the schoolhouse. The first minister was the Reverend Stephen Collyer. In 1914, this original church was moved from its location on West Orange to 1518 Pioneer Boulevard in the business district.

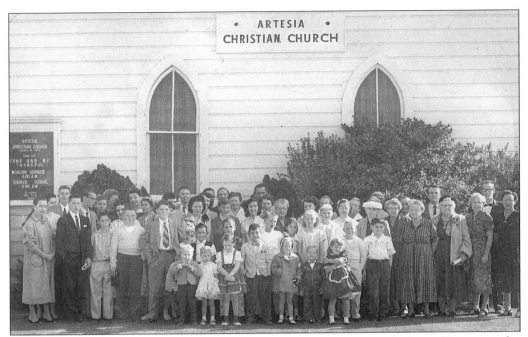

In 1959, the Christian Church on Pioneer was sold to the General Telephone Company, who tore the church down and constructed a parking lot in its place. The Christian Church purchased property and built a new church at 11625 East 178th Street. They held their first service September 2, 1962.

When Pioneer School was built in 1910, the original rustic, wooden schoolhouse was moved to the downtown business district and converted into a store building. No longer needing the old school bell, it was given to the Artesia Christian Church, with the proviso that it *never* be taken out of Artesia. The bell remains at the Christian Church today. Pictured with the bell are the following: (left to right) Rev. Darrel Manson, June Lawson, Frances Row, Hank Gray, and James Van Horn.

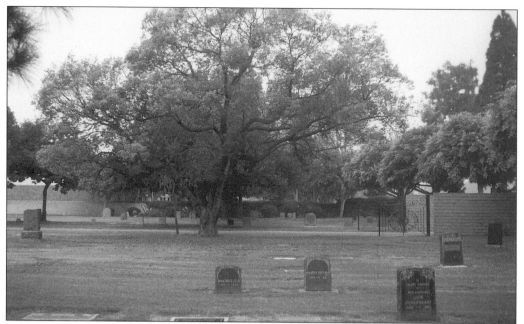

The first recorded burial in the Artesia Cemetery was that of Mr. John P. Collins (1814–1882). In 1928, a petition by Mrs. Margaret E. Purviance and 50 other property owners was presented to the Los Angeles County Board of Supervisors requesting that this donated land be designated as a public cemetery. The Artesia Cemetery District is a tranquil, 14-acre site located at 11142 East Artesia Boulevard, Cerritos. Today it continues to serve the residents of Artesia, Cerritos, Hawaiian Gardens, and portions of Bellflower, Lakewood, Long Beach, and Norwalk.

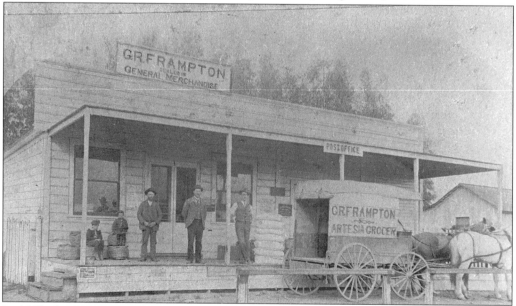

In 1882, the first store was opened for business in Artesia under the direction of Doc Wilson, offering various items for the home and farm. The Frampton family purchased the store, pictured here in 1895. The Frampton Store was located on Pioneer Boulevard and housed the local post office. (Photo courtesy of Howard Frampton.)

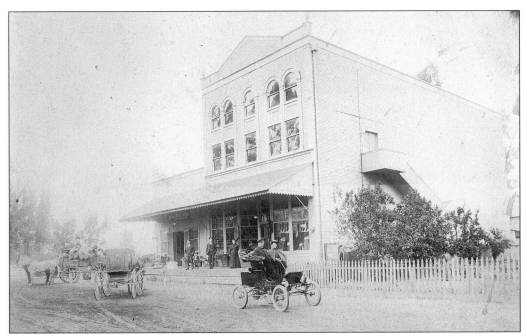

In 1904, a new two-story building was built next door to the Frampton Store. The lower floor was for merchandise; the upper two floors were for hotel use.

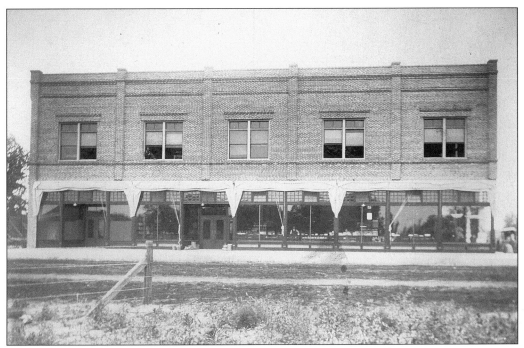

In 1905, the first brick building erected in Artesia was for the Scott and Frampton Company, at the southwest corner of Pioneer and 187th Street. The first floor of this building was used for general merchandise, while the upper floor was used as a meeting hall. (Photo courtesy of Howard Frampton.)

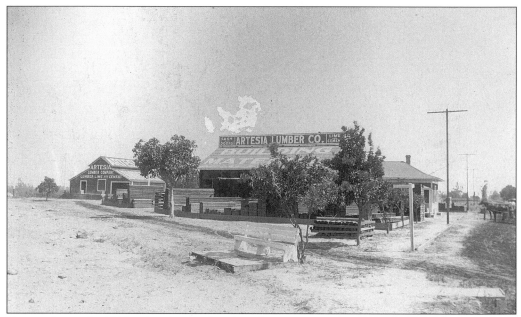

During the early 1900s, the Artesia Lumber Company was located on the southeast side of Pioneer Boulevard below the railroad tracks, across from the Artesia Train Depot.

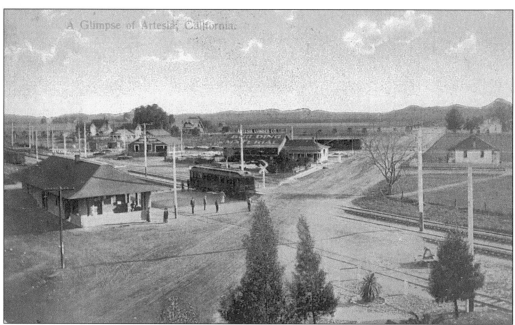

In the late 1890s, the only available railway service was on the Southern Pacific Railway, which was built through Norwalk some 3 miles from Artesia. In the early 1900s, Henry E. Huntington established the Pacific Electric Railroad in order to sell and develop vast tracts of real estate. These 50-foot-long Red Cars were made of wood and steel and painted crimson with gold letters and trim. In 1905, the Pacific Electric began passenger and freight service between Los Angeles and Santa Ana. Mr. Charles E. St. John was the Railway Agent in 1914. (Photo courtesy of Dora Bell.)

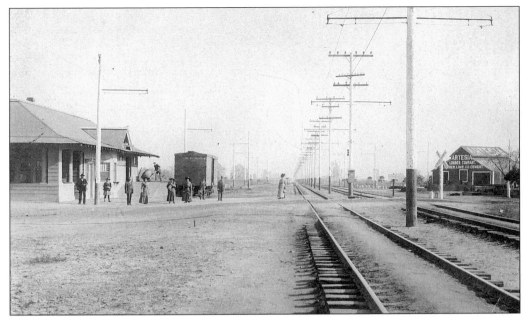

Many small dairy farms were situated along the right of way and at various locations along the railroad track. Farmers could place milk cans on small platforms to be picked up by the trains. The "milk run" train would leave Santa Ana about 3:30 a.m., getting the milk to Los Angeles in time for the milk processing plants. When the Santa Ana branch of the Pacific Electric was completed, developers were able to create a town site, and the building of the present town of Artesia began.

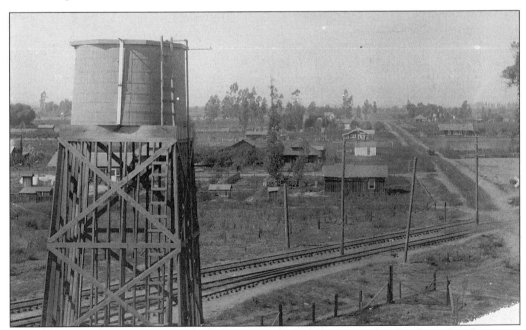

Looking westward down 187th Street, a water tower and rural scene border the railroad route to Los Angeles. As automobile traffic increased in the 1930s, Pacific Electric passengers declined in number. The last Red Car made its final run on the Long Beach line in 1961.

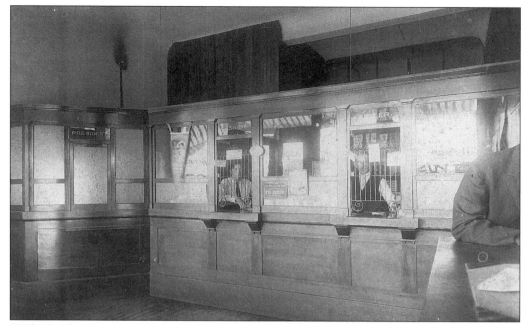

With the development of the business district, the First National Bank was organized with Herman W. Wellman of Los Angeles as president, C.B. Scott as vice president, and George R. Frampton Jr. as cashier. The above photo shows George and Albert Frampton as cashiers in the bank in 1906.

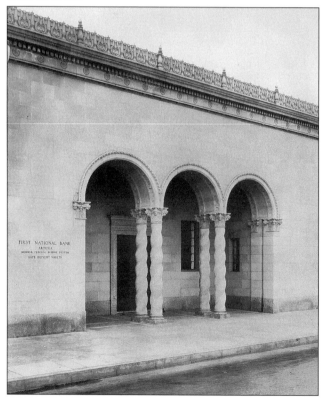

The new bank building was built in 1924 at the northwest corner of Pioneer Boulevard and 187th Street. George Frampton was its president until it was sold in 1931. Due to the Great Depression, the bank was forced to close its doors in 1932. In addition to serving several banks, this building also housed the ABC Discount Store, House of James Clothing Store, and currently, the General Bank.

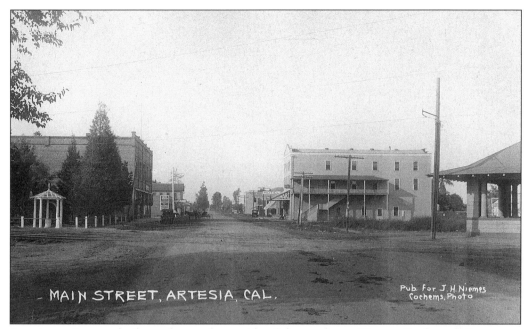

A train station was built on the northeast side of the tracks on Pioneer Boulevard. Passengers could wait for the Red Car at a small park across the street.

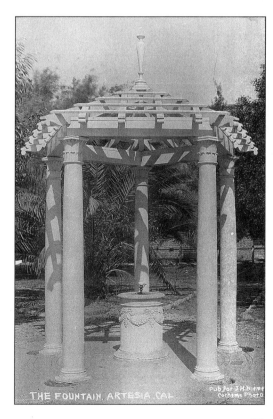

The park had a gazebo with a drinking fountain surrounded by palm trees. The Long Beach Earthquake destroyed this fountain in 1933. (Photo courtesy of Dora Bell.)

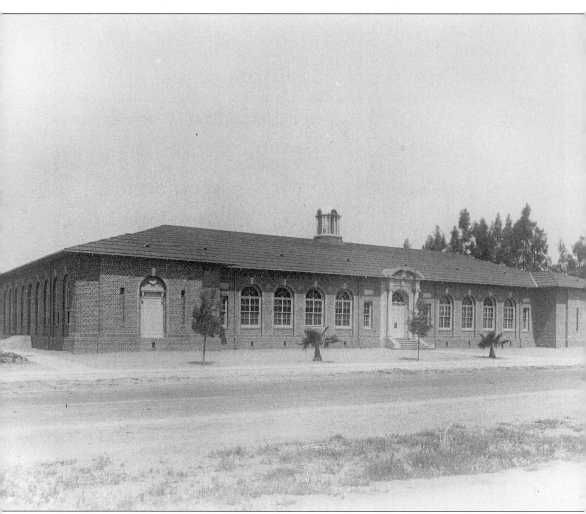

The first brick school building, the Artesia Grammar School, affectionately known as "the Pioneer School," was constructed in 1910. Additions to the school were made from 1922 to 1929. All of the children in Artesia attended school in this beautiful building with many classrooms. In 1933, the school sustained earthquake damage, and classes were held for a period of time across the street at the Methodist church. In 1937, a pedestrian underpass was constructed to provide safe passage for school children crossing the thoroughfare of Pioneer Boulevard. The underpass was closed in 1954. The last class graduated in 1949, although portions of the building were still in use up until the school was closed in 1954. In 1952, the Red Cross flood victims took refuge in the school. The building was razed in 1956. For 39 years, this school served the needs of both the students and the community at large.

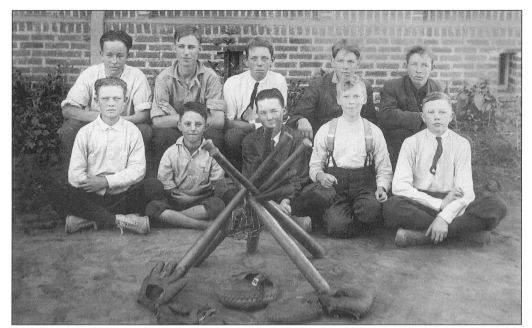

Members of the Pioneer School Baseball Team (1914–1915) included the following, from left to right: (front row) unidentified, Verne Elliott, Francis Marshall, Everett Edgerton, and unidentified; (back row) Harold Patton, Harold Edgerton, unidentified, Kent Garner, and unidentified.

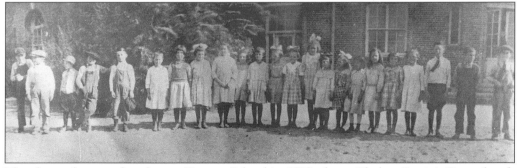

The above photograph, taken at Pioneer School in 1920, shows Thelma Patricia Ryan, fourth from the right. She would later be known as Pat Nixon, First Lady of the United States.

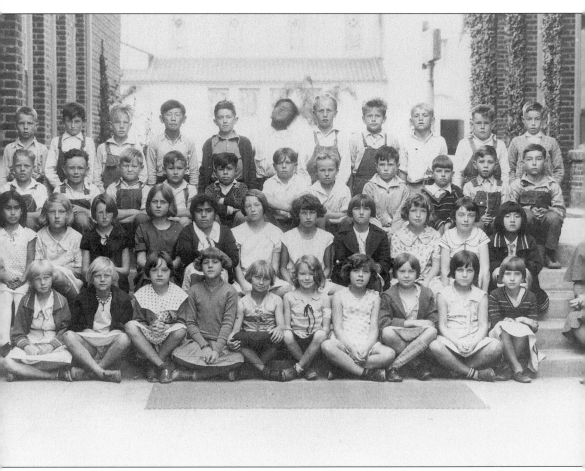

This class picture, taken sometime in the early 1930s, reflects the diversity already present in the community of Artesia. There were school children of Asian, Anglo, Dutch, Portuguese, and Mexican descent. Seated on the right is Veronica Mountain (Little), who taught in the district from 1927 to 1954.

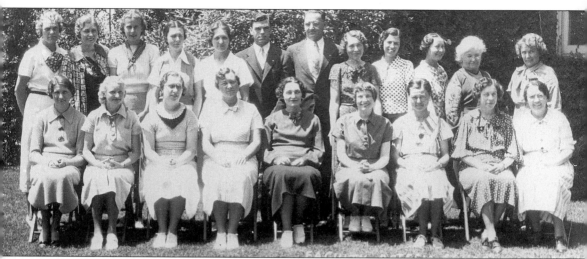

Members of the 1936 faculty at Pioneer School included the following, from left to right: (back row) Faye Ross, unidentified, unidentified, unidentified, unidentified, unidentified, unidentified, Veronica Mountain (Little), Eleanor Kent, Lillie Lee, Miss Heller, unidentified; (front row) Helen Rich Wittmann, unidentified, Leona Myler, Jessie Wile, Mary Bragg, unidentified, Clara Mae Tracy, unidentified, and Lucy Pannell.

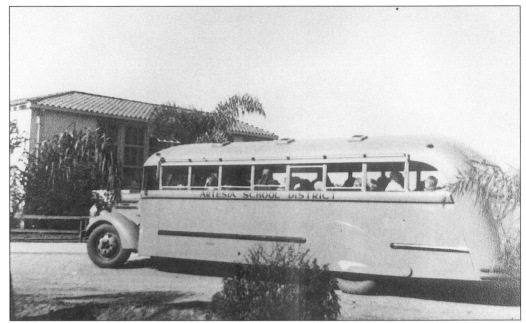

One of the first school buses to be used in the Artesia School District is pictured in front of the Clifton School in 1942. In 1965, the Artesia School District, the Bloomfield School District, and the Carmenita School District joined together to become the ABC Unified School District. The first Board of Trustees for the Unified District included the following: Richard A. Franks, president; Gretchen Whitney, vice president; Daniel K. Morrison, clerk; and members J. Byron Dorius, M.D., Lynn W. Fletcher, Venn W. Furgeson, and Paul A. Warren.

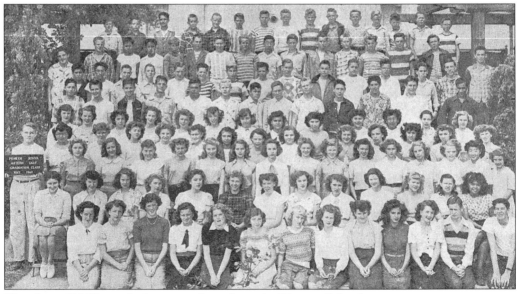

The class of 1949 was the last to graduate from the Pioneer School.

30

# Three
# CIVIC LIFE

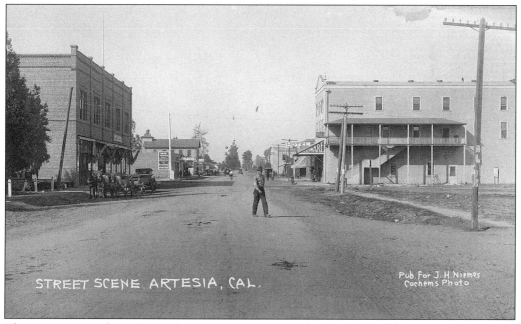

This street scene down Main Street in Artesia was taken in 1912. (Photo courtesy of Dora Bell.)

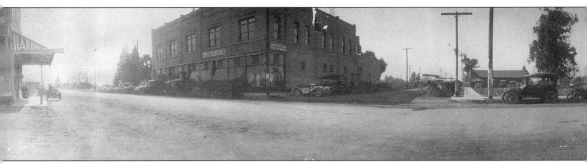

A panoramic view shows the Scott and Frampton brick building.

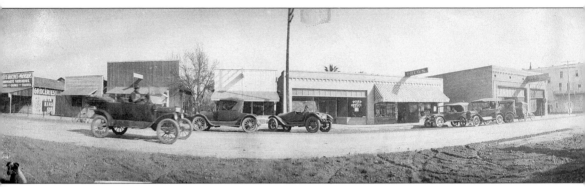

This scene depicts the east side of Main Street (Pioneer Boulevard) in about 1911.

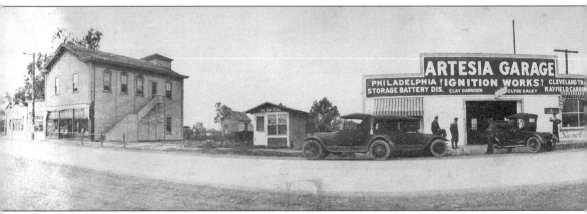

This 1910 photograph of Pioneer Boulevard shows the Artesia Garage on the right and the newly moved and converted original Artesia Grammar School on the left.

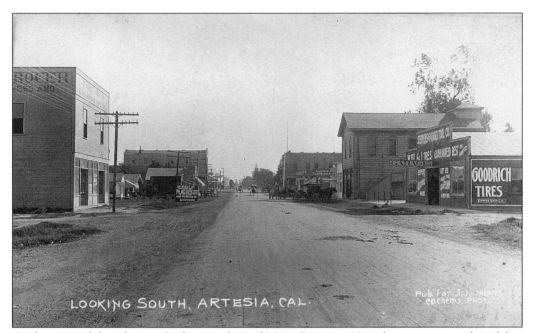

At the time of this photo, which was taken of Main Street in 1914, horses were as plentiful as cars, as Artesia was then the trade center of a farming area.

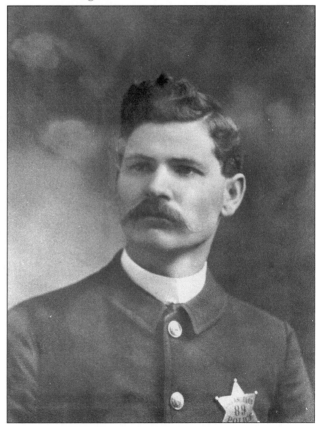

Charles E. Sebastian grew up in Artesia and was baptized in the Christian Church. Later in life, he became the chief of police of Los Angeles. Mr. Sebastian served as mayor of Los Angeles from 1915 to 1916.

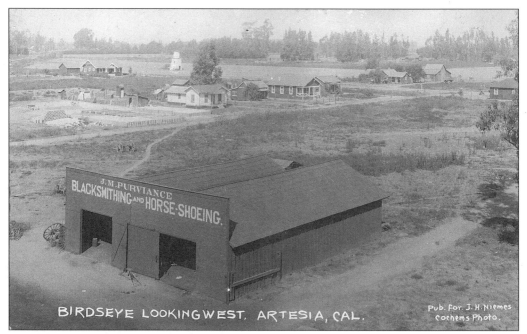

This bird's-eye view of Artesia, looking west, plainly shows the blacksmithing and horseshoeing business of J.M. Purviance. (Photo courtesy of Dora Bell.)

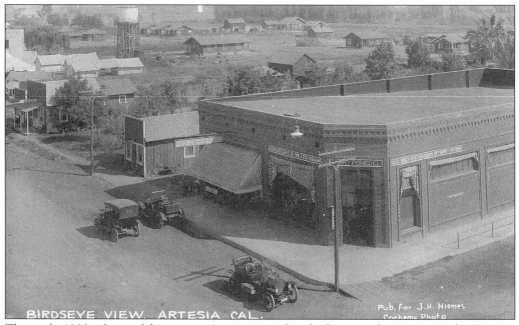

This early 1900s photo of downtown Artesia was taken looking north on present-day Pioneer Boulevard from 187th Street. The 1933 earthquake destroyed the building on the corner, Pondel General Store, purveyor of groceries, meats, and grain.

34

Not all of the water in Artesia came from wells. The floods of 1913 covered a wide area of the town and disrupted daily life.

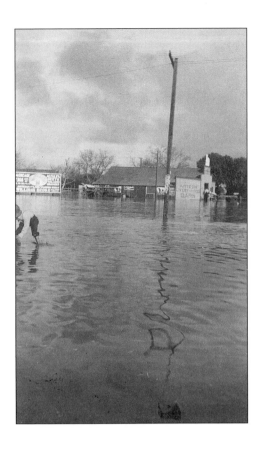

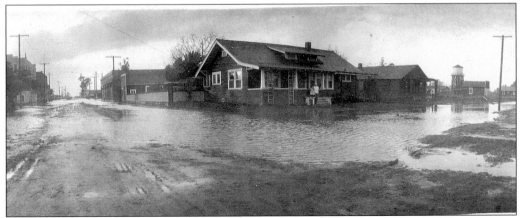

Floodwater surrounded this Artesia residence and made traveling the streets difficult.

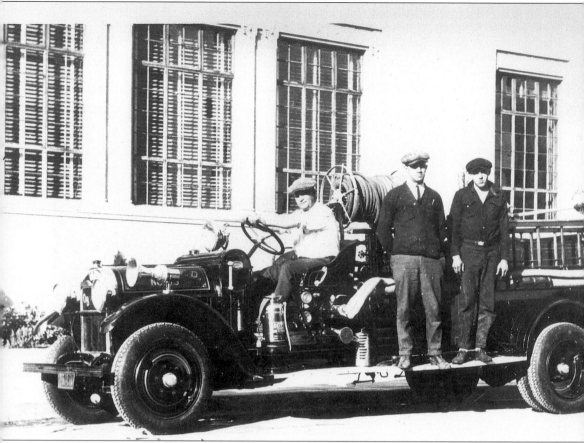

The Artesia Volunteer Fire Department had its beginnings in 1918. The equipment consisted of a hand-pulled cart, fire foam, and hoses. In 1925, the Artesia Fire District was formed by Leu Boers, Ed Corcoran, Charlie Scott, Butch Brunswicker, and John H. "Doc" Niemes. A fire truck was purchased for $5,285 and was kept in a service station on the north side of Pioneer and 187th Street. Leu Boers was made the fire chief. His salary was $50 per month, including the station rental. When the service station was destroyed in the 1933 earthquake, Chief Boers moved the fire truck to his home at the southeast corner of 183rd Street and Arline Avenue. During business hours, he kept the fire truck at his service station at 186th and Pioneer. Volunteers during this time were Leu Boers, Bert Boers, George Gaines, and George Schnabel. (Courtesy Dick Friend, LA County Fire Department, 1999.)

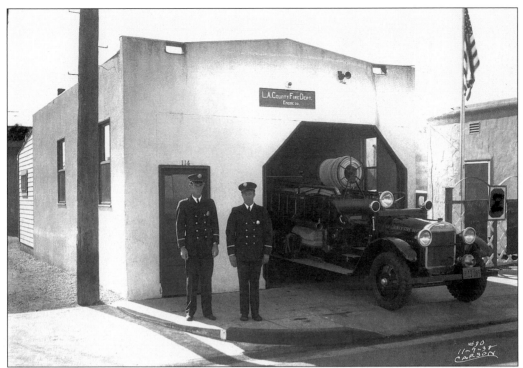

In 1934, a fire station was built at 11814 East 186th Street. One regular fireman was assigned to a 24-hour shift, and volunteer "callmen" were used to assist the fireman. Volunteers included Elmer Julian, Chester Lawson, and George Moss. By the time these men retired in 1970, they had a combined total of nearly 90 years of volunteer service. (Photo courtesy of Dick Friend, LA County Fire Department.)

In 1949, a new location was acquired for Los Angeles County Fire Department Station No. 30 at 18641 South Corby Avenue. In 1985, Station No. 30 was moved to the city of Cerritos. Currently, the Corby Avenue building has been restored and houses the Artesia Chamber of Commerce.

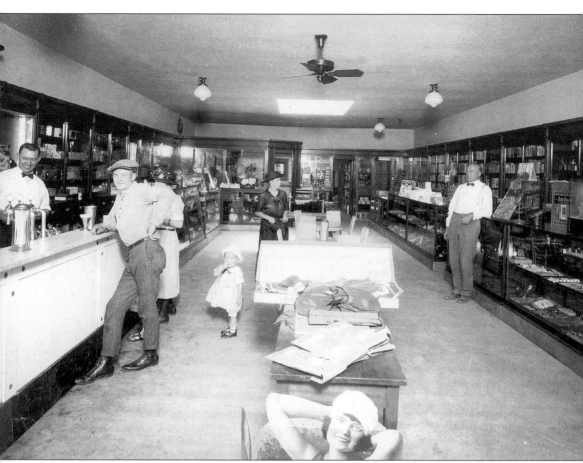

The Regal Drug Store, located at Pioneer and 187th Street, carried drugs, confectioneries, cigars, Kodaks, sporting goods, phonographs, musical instruments, jewelry, toys, and magazines. John H. "Doc" Niemes, pictured on the right, owned the drugstore. George Gaines appears on the left behind the counter. Doc Niemes served as Artesia Chamber of Commerce's first president in 1925. Until incorporation in 1959, the Chamber of Commerce was the primary liaison between the citizens and the various agencies of Los Angeles County. Doc Niemes served as a school board member from 1931 to 1950. The John H. Niemes School, located at 16715 Jersey Avenue, was named after him in 1962.

William G. Mathews was the first constable in the town of Artesia, and he served in law enforcement until his retirement in 1949. Mr. Mathews was one of the original signers to establish the Chamber of Commerce in 1923, and a member of the Artesia School District Board for many years. The Mathews family donated land for the building of Luther Burbank School, located at 17711 Roseton Avenue. He was instrumental in the incorporation of the city and was elected Man of the Year by the Chamber of Commerce in 1965.

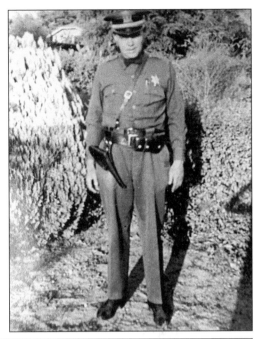

FORM 146

**COUNTY OF LOS ANGELES**

LOS ANGELES, CALIF., _____ 192__

To _William G. Mathews_ _Artesia_ _Calif._ DR.

FOR EXPENSE INCURRED IN USE OF OWN AUTOMOBILE NO. _____, EXCLUSIVELY FOR COUNTY BUSINESS.

_Constable_ _Sheriff_ DEPARTMENT, AS AUTHORIZED BY BOARD OF

SUPERVISORS ON_____ 192__

| DATE | SPEEDOMETER READING OUT | SPEEDOMETER READING IN | MILES | FROM | TO | PURPOSE OF TRIP |
|---|---|---|---|---|---|---|
| 13 | 15925 | 15944 | 19 | Artesia | Hynes | Locating stolen ho |
| 14 | 15944 | 15952 | 8 | Artesia | Norwalk | Machine stolen |
| 14 | 15952 | 16009 | 57 | Artesia | Around dist | Patroling @ invest |
| 15 | 16009 | 16030 | 21 | Artesia | Santa Fe Springs | call about abandon |
| 16 | 8318 | 8339 | 21 | Artesia | Santa Fe Springs | Invest report dist |
| 16 | 8339 | 8361 | 22 | Artesia | La Mirada | Arresting boys |
| 16 | 8361 | 8405 | 44 | Artesia | L.A. | Pris. J. Smith |
| 17 | 16042 | 16047 | 5 | Artesia | Near Artesia | Call about tramps |
| 17 | 16047 | 16096 | 49 | Artesia | Around dist | Patroling @ invest |
| 18 | 16096 | 16104 | 8 | Artesia | Norwalk | boy killed by auto |
| 18 | 16104 | 16112 | 8 | Artesia | Norwalk | releasing auto |
| 18 | 16112 | 16124 | 12 | Artesia | Carmenita | Arresting A Mille |
| 19 | 8405 | 8465 | 60 | Artesia | Orange Co. Line & L.A. | taking to county jail |
| 20 | 8465 | 8471 | 6 | Artesia | Near Artesia | serving order to app |

TOTAL 340    MILES @ 6¢ PER MILE

I HEREBY CERTIFY THAT THE ABOVE CLAIM AND ITEMS AS THEREIN SET OUT ARE TRUE AND CORRECT: THAT NO PART THEREOF HAS BEEN HERETOFORE PAID AND THAT THE AMOUNT THEREIN IS JUSTLY DUE.

_William G. Mathews_ ____CLAIMANT

FALSIFYING THIS STATEMENT WILL BE CAUSE FOR DISMISSAL.
SPEEDOMETER READINGS MUST BE GIVEN FOR BEGINNING AND END OF TRIP.

This document is a log sheet for February 25, 1925. Mathews's duties that day included scouting stolen horses, making arrests, and patrolling the area.

The Artesia Hospital was owned and operated by Carlyle L. Ahrens, M.D. It was located at the corner of Pioneer and 183rd Street. It was later named the Artesia Community Hospital, under the direction of Russell B. Clark, M.D.

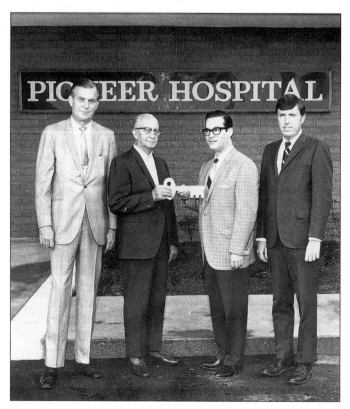

A.J. Padelford and Son was contracted by Dr. Walter T. Mullikin to build Pioneer Hospital in 1960. Located at 17831 South Pioneer Boulevard, this hospital served the community under Dr. Mullikin's leadership until 1997. Pictured from left to right are the following: William Kemper, hospital administrator; A.J. Padelford, contractor; Dr. Mullikin; and John McDonald, assistant hospital administrator.

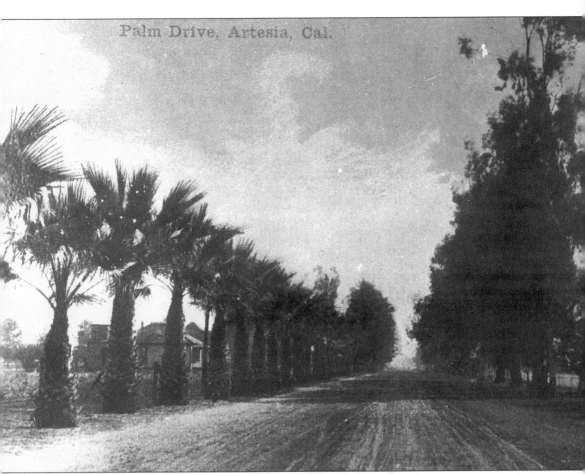

The palm trees lining Pioneer Boulevard north of South Street were standing when that boulevard was a narrow dirt road in the open country. The big pine on the left, at Artesia Boulevard, was cut down for street widening and parking in the late 1920s.

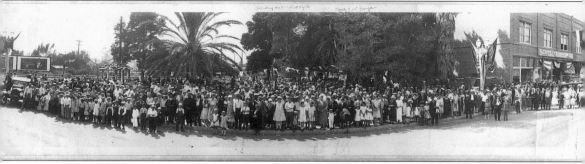

In 1927, there was a community celebration to honor the completion of the street lighting project on Pioneer Boulevard. School was closed, a parade was held, and a picnic took place where hot dogs, soft drinks, and cotton candy were free for all. In the afternoon, the citizens of Artesia gathered at 187th Street and Pioneer Boulevard for this community picture.

John C. Porter, another young boy who grew up in Artesia, also became the mayor of the city of Los Angeles from 1929 to 1933.

# *Four*

# PEOPLE OF FAITH

A "Mexican Quarter" was identified on an Artesia insurance map in 1929. The boundaries were 188th Street on the north, South Street on the south, Alburtis to the east, and Jersey to the west. The Mexican Methodist Church was established in 1922 at 18823 Jersey Avenue. Church records state that a membership of 31 persons had been organized in the "rudest" of pool halls. The student pastor of the time, Tranquilo Gomez, performed 30 baptisms and claimed 20 converts (Commission of Archives and History, The California Pacific Conference, United Methodist Church Archives, School of Theology, Claremont). The church became the Kynett Memorial Mexican Church, in memory of the wife of the founder of the Board of Home Missions and Church Extension. In its later years, the church became the "El Gethsemani Methodist Church." In the 42 year history of this church, 11 pastors served the congregation. It closed its doors in 1964.

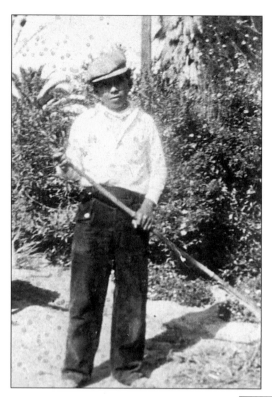

Families lived within the tightly knit community of the "Mexican Quarter" who were primarily farm workers in the fields harvesting celery, lettuce, and tomatoes. Typically, women stayed home. Those who did work drove to Hunt's Packing House in Fullerton. Pictured here is Joe Lopez working on the Frampton Farm. Joe and his family were members of the Mexican Methodist Church. (Courtesy Ramona Mendez Lopez, 1999).

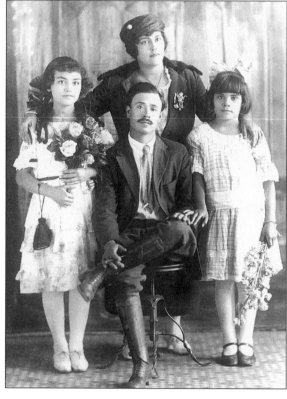

Jose and Ramona Aguila and their daughters, Aurora and Clemontina, are pictured here. Ramona owned and operated The Spanish Kitchen, a house that was converted into a restaurant in front, located at 18743 South Pioneer Boulevard. After the Spanish Kitchen was torn down, a bar called El Casino was built by Pedro Barraza. El Casino became the gathering place for the men of the neighborhood. Three blocks away on Jersey and South Street, families shopped at the grocery store known as El Mercado, owned and operated by the Sugiyama family (Courtesy Ramona Mendez Lopez, 1999).

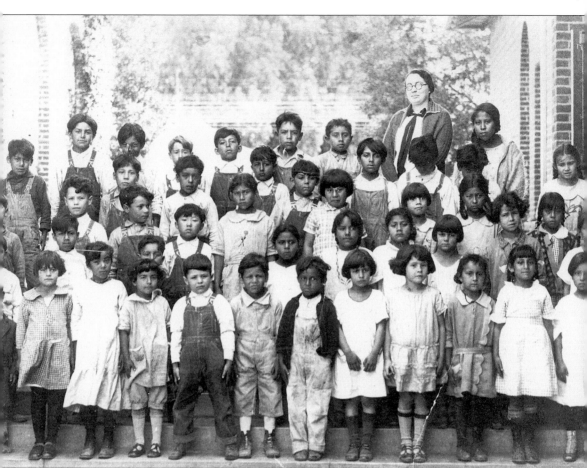

In this class picture from the Artesia Grammar School, Joe Lopez is standing in the last row, fifth from left. (Photo courtesy of Ramona Mendez Lopez.)

In 1920, Ramona Mendez was born in the living quarters of the Spanish Kitchen, which was owned and operated by her godmother, Ramona Aguila (pictured center). On the left is Epitacia Mendez, Ramona's grandmother, and behind Ramona is her grandfather, Rafael Mendez. Vicenta Mendez, Ramona's mother, is pictured on the right. (Photo courtesy of Ramona Mendez Lopez.)

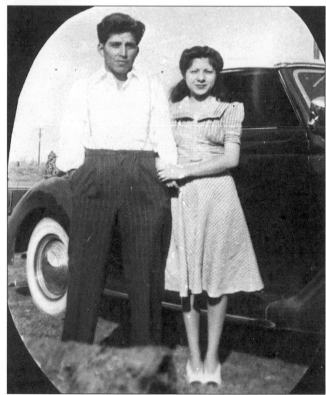

Ramona Mendez and Joe Lopez were married in 1938. When they were married, they left the neighborhood and moved into a house on Arline, where Mrs. Lopez still lives today. (Photo courtesy of Ramona Mendez Lopez.)

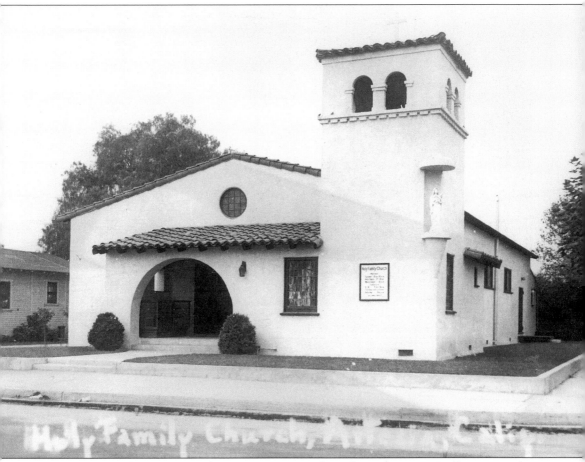

In the early 1920s, dairymen, mostly Portuguese, came from the San Joaquin Valley to ease the shortage of dairyhands in Artesia. Many of them had emigrated from Portugal and the Azores Islands. In 1928, the Holy Family Parish came into existence with the arrival of Father Manuel Vicente. The first mass of the new parish was held in the Frampton Hall, upstairs in the Scott and Frampton Building. Father Vicente's temporary residence was at the old Parker Hotel on Pioneer Boulevard. This picture shows the first church building erected in 1931 on Corby Avenue. (Photo courtesy of Kathy Gonsalves Scott.)

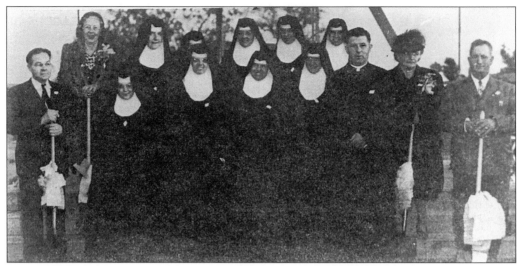

Groundbreaking ceremonies for Our Lady of Fatima School and Social Center were held on Sunday, December 7, 1947. Among the people present were Father Patrick O'Connor, parish priest; teachers from the Sisters of the Immaculate Heart of Mary; Mrs. John C. Sullivan, president of the Altar Society; Mrs. Joe Fernadez Sr., president of Our Lady of Fatima Society; Mr. L.C. LaPorte, president of the Holy Name Society; and Mr. Jack Gonsalves Sr., who acted on behalf of the men of the parish. (Photo courtesy of Kathy Gonsalves Scott.)

Our Lady of Fatima School Gymnasium and Convent were dedicated on August 22, 1948. The Sisters of the Immaculate Heart of Mary taught classes beginning in the school in September of that same year. The gym had a seating capacity of 500 at dinner and approximately 800 at performances. During the 1950s, the Artesia Chamber of Commerce held its annual banquet in this facility. (Photo courtesy of Kathy Gonsalves Scott.)

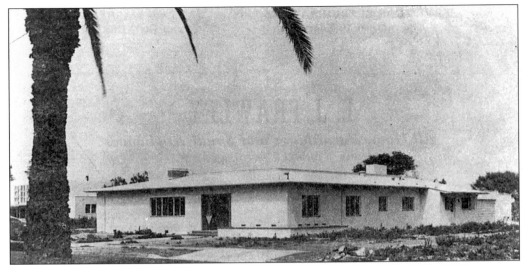

The new rectory contained two offices, three priests' accommodations, housekeeper's quarters, dining room, kitchen, pantry, and service porch.

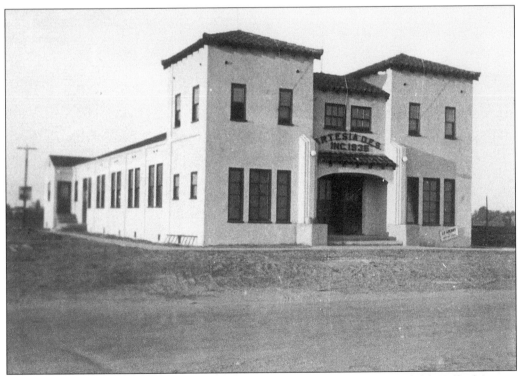

The D.E.S. (*Divino Espirito Santo* in Portuguese, Divine Holy Spirit in English) Hall of Artesia was incorporated in 1935. Located at 11903 Ashworth, the "Portuguese Hall" has been the site of numerous parish and community events.

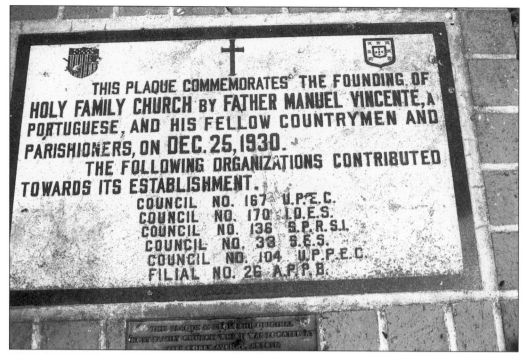

THIS PLAQUE COMMEMORATES THE FOUNDING OF HOLY FAMILY CHURCH BY FATHER MANUEL VINCENTE, A PORTUGUESE, AND HIS FELLOW COUNTRYMEN AND PARISHIONERS, ON DEC. 25, 1930. THE FOLLOWING ORGANIZATIONS CONTRIBUTED TOWARDS ITS ESTABLISHMENT.

COUNCIL NO. 167 U.P.E.C.
COUNCIL NO. 170 I.D.E.S.
COUNCIL NO. 136 S.P.R.S.I.
COUNCIL NO. 33 S.E.S.
COUNCIL NO. 104 U.P.P.E.C.
FILIAL NO. 26 A.P.P.B.

This plaque is from the original Holy Family Church, which was located at 18803 Corby Avenue.

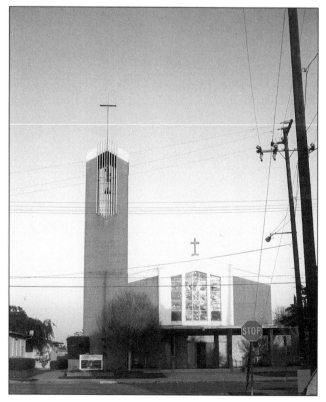

The new parish church, located at 18708 South Clarkdale Avenue, was built in 1960.

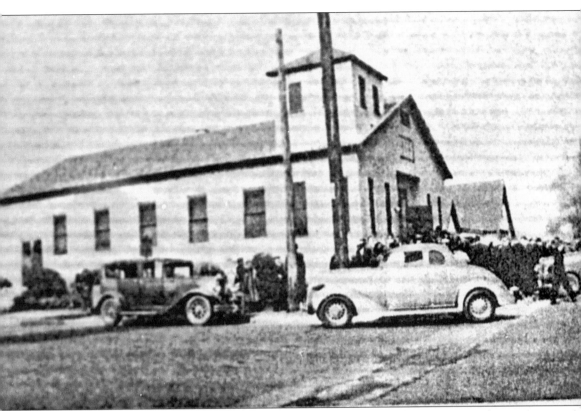

In the 1920s, the choice dairy property in Artesia began to attract Dutch dairymen and natives of the Netherlands and Friesland. The Artesia Reformed Church was organized on April 11, 1932, and met at the Artesia Woman's Club. The first minister was the Reverend M. Flipse. After the 1933 earthquake, the clubhouse had to be rebuilt. The Dutch congregation was too large to meet in anyone's home, so church services were held in the Jongsma family's old red hay barn. Benches and a pipe organ were installed for the purpose of worship. The first church at 18523 South Arline was built in 1933 and enlarged in 1938. Most services were in Dutch until 1955, when it was decided that services would be in English. (Photo courtesy of Josephine Herrema Busman.)

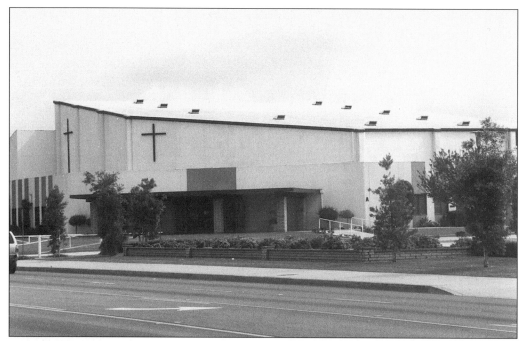

In 1970, the congregation of the Artesia Reformed Church purchased 10 acres of land at 18800 South Norwalk Boulevard for a walk-in, drive-in church. In July 1971, by vote of the congregation, the name of the church changed to New Life Community Church.

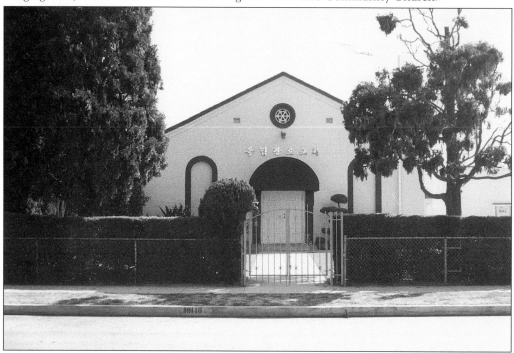

The Korean Independent Presbyterian Church is located at 18116 Arline Avenue. At one time, it was the home of the Christian Science Church, established in 1912. Mrs. Charles Gahr was the First Reader; Mrs. William Philips was the Second Reader.

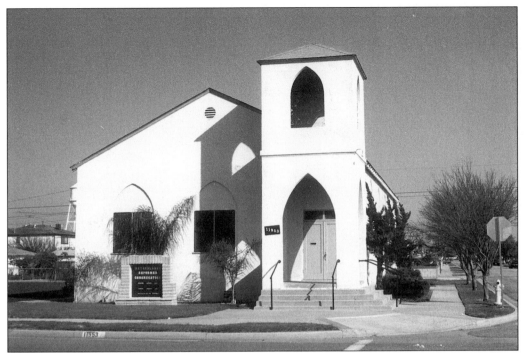

The Netherlands Reformed Congregation was founded in 1954 with Rev. Gazuiderveld leading the congregation.

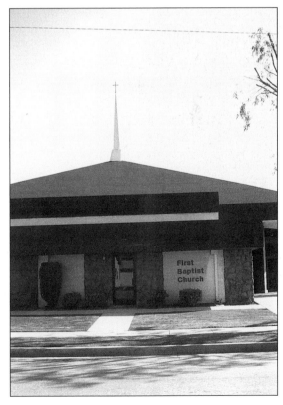

The First Baptist Church was established in 1948. The Reverend F.M. Box was the first minister.

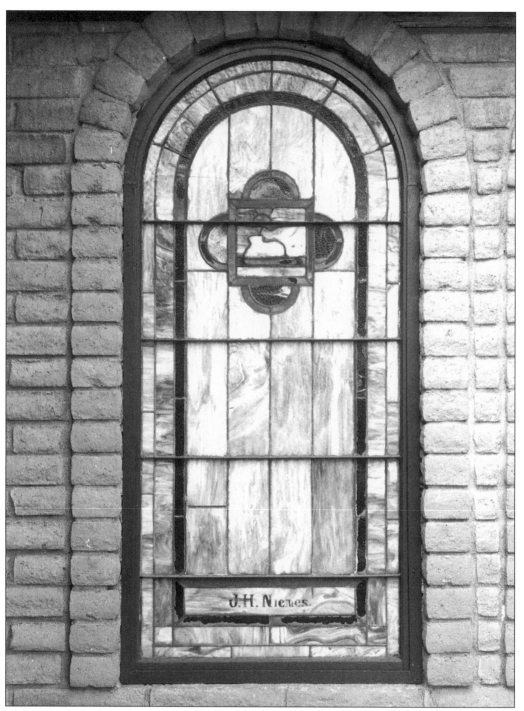

This stained-glass window was originally part of the 1923 Methodist Church Building. When the church moved to its present location, this window honoring Doc Niemes, and other windows like it, were preserved in a memorial garden. From its beginning, Artesia has been home to people of faith, honoring their distinct heritages as they have honored God. This preservation is an act of beauty as it incorporates the past into the future.

# Five

# DISASTER AND
# DEVELOPMENT

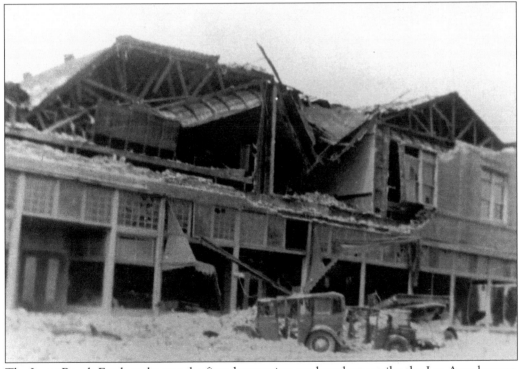

The Long Beach Earthquake was the first devastating earthquake to strike the Los Angeles area after it had become a metropolitan center. It hit at 5:54 p.m., March 10, 1933, along the Newport-Inglewood fault. The epicenter was located 2 miles offshore, southwest of Huntington Beach. It registered 6.3 on the Richter scale and struck heavily populated areas, causing 102 fatalities and millions of dollars in damage. Pictured here is the front view of the damaged Scott and Frampton Building at Pioneer and 187th Street.

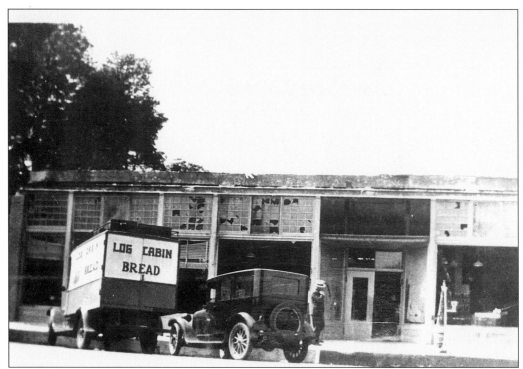

The Scott and Frampton Building appears here after earthquake debris was cleared away. Although there was structural damage to businesses and residences, there were only two known fatalities: Steve Green and George Stone. They died in front of this building.

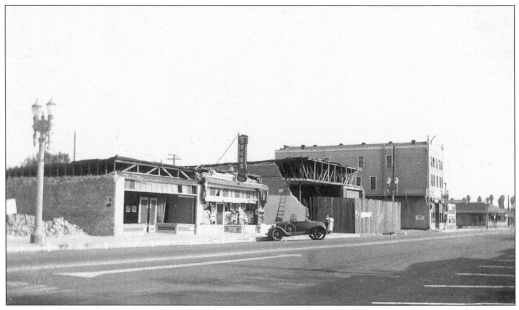

These buildings, located on the east side of Pioneer Boulevard, also suffered structural damage. (Photo courtesy of Louise Howard.)

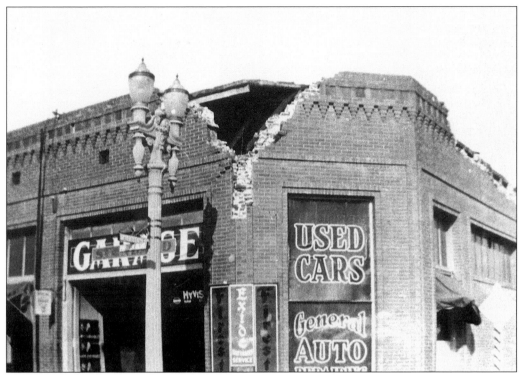

The Artesia Garage, formerly the Pondel General Store, located on the northeast corner of Pioneer and 187th Street, was severely damaged and could no longer be used.

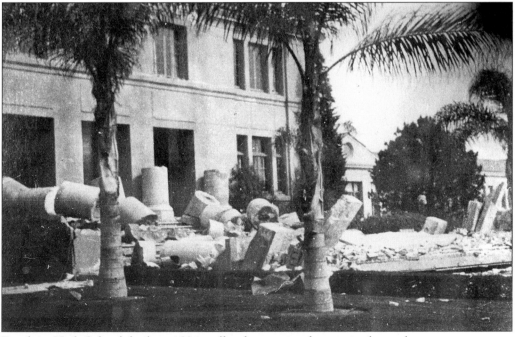

Excelsior High School, built in 1924, suffered extensive damage in the quake.

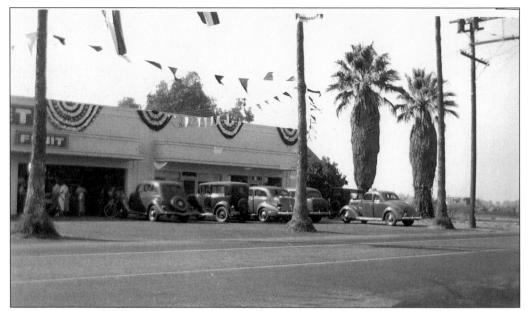

In the years following the earthquake, businesses rebuilt, and new ones developed. The Pioneer Market, built in 1937, was operated by Johnny Moore. (Photo courtesy of Barbara Frampton Applebury.)

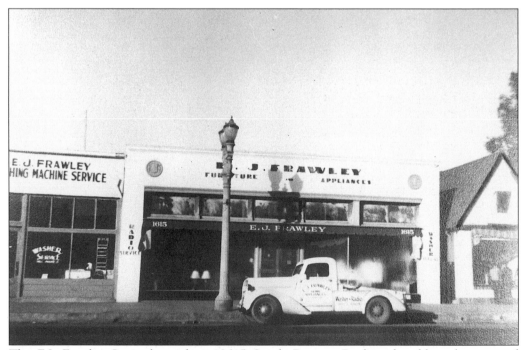

The E.J. Frawley Store, located at 18615 South Pioneer Boulevard, sold appliances and furniture. Later occupants of this building were Dirksen's Appliances and Postma Furniture. (Photo courtesy of Barbara Frampton Applebury.)

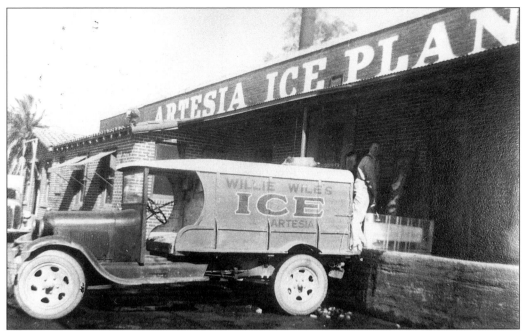

The Artesia Ice Plant opened in 1929. The source of water for the plant continues to be an artesian well. The water is pumped out, put through a softening process, and then frozen in a tank that resembles a huge ice tray. The plant can produce 100 tons of ice per day. Harvey Frampton bought this operation in 1967, and his son, Bill Frampton, eventually took over in 1978. Pictured here is Willie Wile, picking up his ice supply for delivery in the community during the 1930s.

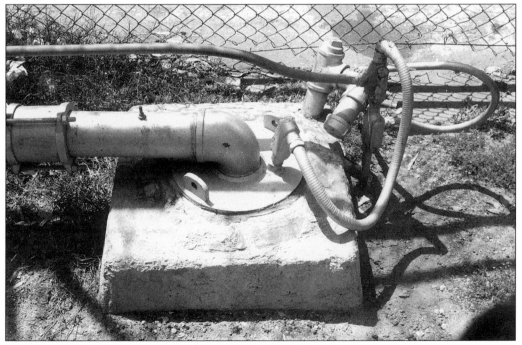

This artesian well continues to be the source of water for the Artesia Ice Company.

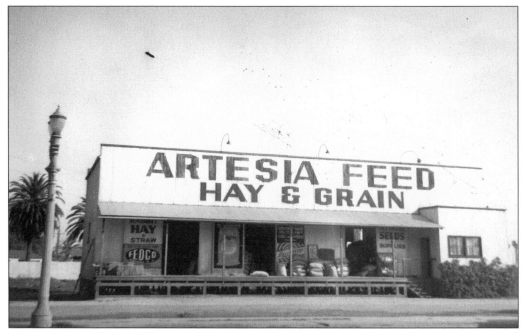

The Artesia Feed, Hay and Grain Store was run for 22 years by Ralph and Louise Howard and their family. When they retired in 1966, it was moved across the street, where their son, Philip, continued to run the business. (Photo courtesy of Louise Howard.)

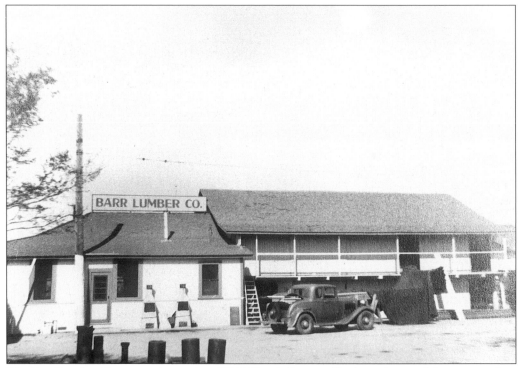

The Barr Lumber Company, located at 18810 South Pioneer Boulevard, served the surrounding communities for many years. (Photo courtesy of Barbara Frampton Applebury.)

*Six*

# COMMUNITY SERVICE

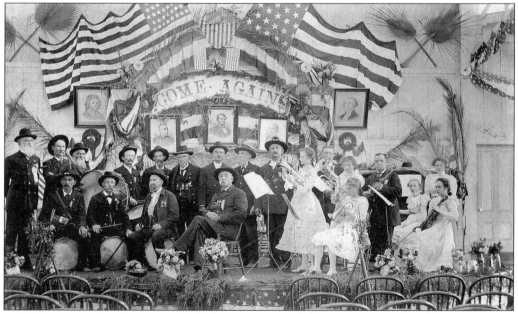

"There is something majestic about Artesia and its people. Since early times, Artesians were indomitable in disasters…always courageous in difficulty and generous in times of need." (*The Artesians*, 1975.) This photograph features Schoefield Halgate's musical band, which honored Civil War Veterans in the 1890s. (Photo courtesy of Gus Thompson.)

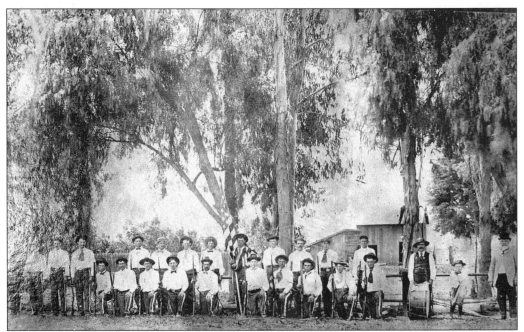

The Artesia Home Guard drilled in readiness for the Spanish American War in 1898.

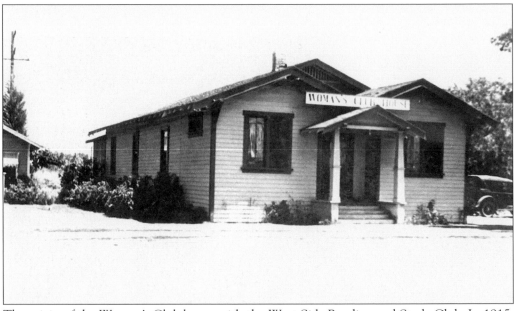

The origin of the Woman's Club began with the West Side Reading and Study Club. In 1915, during World War I, the Artesia Woman's Club was organized "to provide mutual support to members and to promote moral and social welfare, civic improvements and education." (*Woman's Club Brochure.*) Its name was changed to the Woman's Club of Artesia on September 24, 1918. In 1919, the Woman's Club purchased the Central Christian Church building at 18522 South Pioneer Boulevard, which became their clubhouse. The Artesia Public Library, founded in 1913, was housed in the clubhouse from 1925 to 1929. The Woman's Club of Artesia-Cerritos was chartered in 1969.

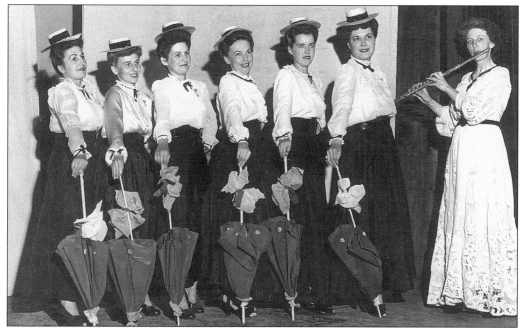

Members of the Artesia Woman's Club perform a musical number in the 1940s. Pictured from left to right are the following: Ann Hershman, Lois McClung, Alicia Poindexter, unidentified, unidentified, Blanche Morey Borden, Lucille VanWagner, and Claire LaBerge, playing the flute. (Photo courtesy of Maude West.)

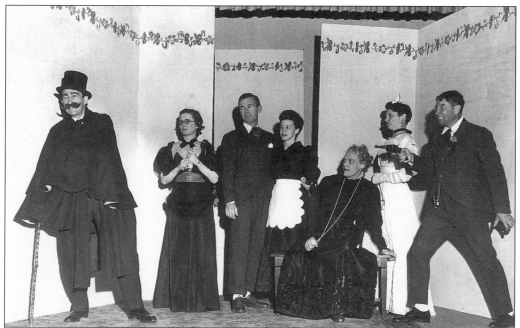

This 1940s melodrama starred the following, from left to right: Dr. Earl Hershman, Mildred Holmes, Dr. Gordon McHatton, Ione McHatton, Faye Ross, Kathleen Wallis, and Mr. Beckner, school superintendent. Both of these events were fundraisers for the Artesia Woman's Club. (Photo courtesy of Maude West.)

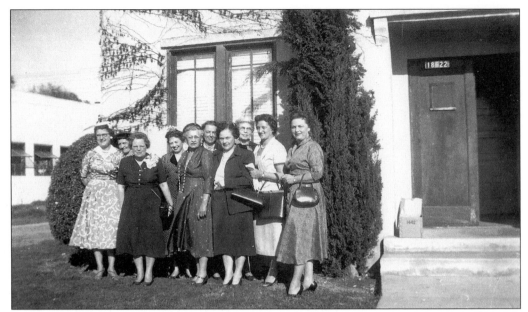

The original Woman's Clubhouse sustained severe damage in the 1933 earthquake. The club made the decision to rebuild on the same site. The new clubhouse was dedicated on January 24, 1934. (Photo courtesy of Ellen Carver.)

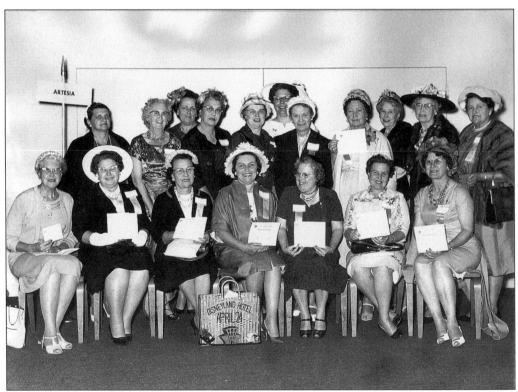

Members of the Woman's Club attended a convention at the Disneyland Hotel during the 1950s. Note the hats and gloves they are wearing. (Photo courtesy of Diane Padelford Young.)

The first organizational meeting of the Masons in Artesia took place in the Frampton Hall, also known as "The Brick Hall," on January 2, 1906. A charter was granted that same year to the Artesia Lodge of Free and Accepted Masons No. 377.

ANNUAL
# INSTALLATION
## OF OFFICERS

Artesia Masonic Lodge
No. 377

Norwalk Masonic Hall

Thursday, January 15, 1948

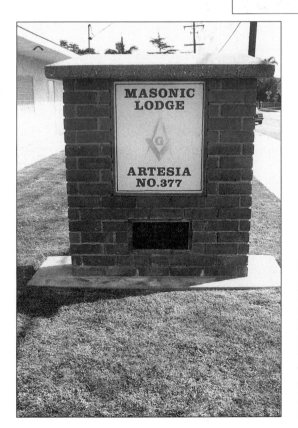

It was not until 1956, when the lodge celebrated it 50th anniversary, that it had its own temple. Under the supervision of Harold R. "Buzz" Whitney, Past Master, and volunteer help on Saturdays, they built the temple in 18 months. Other organizations using the lodge are Order of Eastern Star, Artesia Rainbow Girls, DeMolay, Odd Fellows, and Rebekahs. The lodge is located at 11531 East 187th Street.

Chartered in 1934, the Artesia Kiwanis Club celebrated its 25th anniversary in 1959. Celebrating from left to right are the following: Ira Holmes, Ebe Sutton, Dr. Pliny Haskell, and Al Little. For many years, the Kiwanis Club sponsored activities that benefited the youth of our community.

The Artesia Lions Club was founded in 1947. The club's community service has included facility improvements in the Artesia Park, providing thousands of eye examinations and glasses for those in need, as well as setting up a Dental Health Clinic. Today it is known as the Artesia-Cerritos Lions Club.

The citizens of Artesia participated in civil defense activities during World War II, which included black outs and air-raid drills.

Kirk Nakakihara remembers hearing his uncle tell of his childhood in the Artesia area. His uncle attended 5th grade at Pioneer School and was a paper boy. His family lived near the Mexican Quarter and shopped at El Mercado, the grocery store run by the Sugiyama Family. Kirk's uncle's family were truck farmers near Del Amo and Gridley Road. During World War II (WW II), Kirk's uncle remembers being taken with his family to the Santa Anita Race Track, one location used as a detention center where Japanese-American families waited to be relocated to internment camps. After WW II, the uncle's family and many other Japanese-American families returned to Southern California. Their goal was to make a better life for future generations. For this effort, Kirk is thankful.

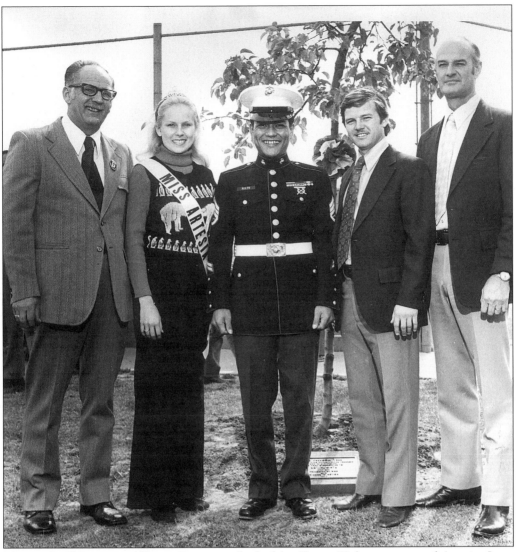

Marine Staff Sergeant Alfonso Riate was flanked by Henry Dirksen, mayor of Artesia; Lucy Sierdsma, Miss Artesia; John Oliver, representing Supervisor James Hayes; and Bob Jamison, Artesia council member. Riate was honored at the Freedom Tree Dedication at Artesia City Park on March 31, 1973. A recently released P.O.W., Riate was lauded along with all young men from Artesia who gave their lives in the Vietnam War and all previous American wars. Trees donated by the city of Artesia and area service organizations were planted in their honor.

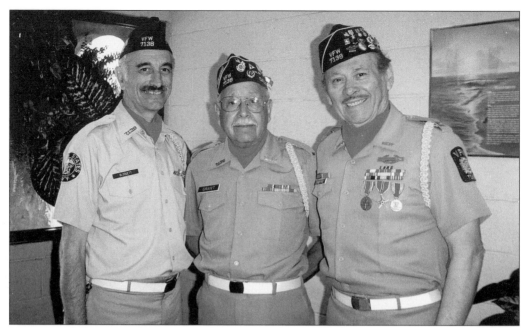

Veterans of Foreign War Glenwood Post No. 7138 Color Guard included the following (pictured from left to right): Senior Vice Commander Richard Blodgett, Chaplain Steve Grant, and Captain Armando Martinez.

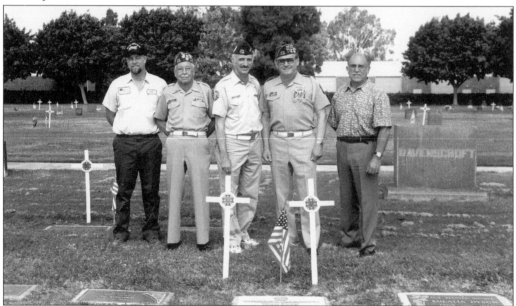

For many years on Memorial Day, members of V.F.W. Post No. 7138 have placed white crosses, in the Artesia Cemetery District, at the graves of those who have served their country on foreign shores. Members of the American Legion Post No. 359 of Norwalk also walk the cemetery and place the American flag on the graves of those who have served their country in the military. Pictured from left to right are the following: Michael Clements, cemetery superintendent; Chaplain Steve Grant; Richard Blodgett, senior vice commander; Armando Martinez, captain; and Lupe Cabrera, cemetery trustee.

# Seven
# Cows!

For many years, this was the face of Artesia.

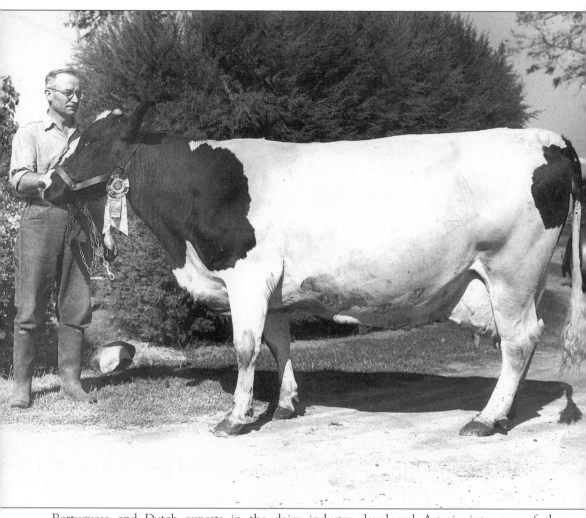

Portuguese and Dutch experts in the dairy industry developed Artesia into one of the most important dairy districts in Southern California. Pictured here is a black and white Holstein cow. Other popular breeds of dairy cattle included Guernsey, Jersey, Brown Swiss, and Red Holstein.

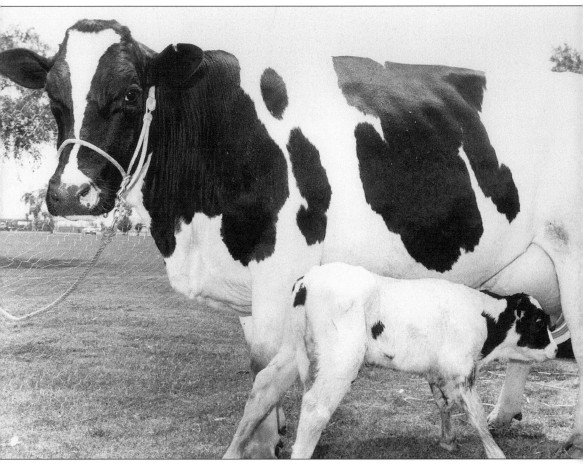

Pictured here are a Holstein cow and calf. A typical milker's day was long and laborious. Mr. Jack Gonsalves recalls his daily schedule as a 17-year-old milker. He would wake up around 1 a.m. to be ready to milk the cows by 2 a.m. He would milk, clean, and feed the cows for six hours straight. At 8 a.m. he would return to the house for breakfast and be in bed by 10 a.m. Around 1 p.m. he would wake up and have lunch. By 2 p.m. milking would resume again for another four hours. Dinner was eaten around 7 p.m., and bedtime was at 8 p.m. Mr. Gonsalves remembers milking 33 cows twice a day by hand. (Jack Gonsalves, 1998.)

Henry Fikse and Adolph Boer, local businessmen and community supporters, advertise the Artesia Dairyland Fair, which was held every spring for ten years starting in 1953. The Artesia Chamber of Commerce sponsored the event.

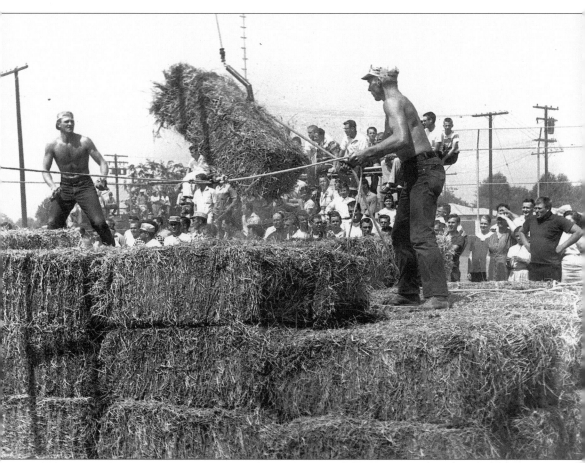

One popular feature of the Dairyland Fair was the "hay bucking" contest. Teams of two men each would load a truck with baled hay and drive the truck to a designated spot to unload it. The goal of the contest was to see which team could load and unload the stack of hay in neat tiers the fastest.

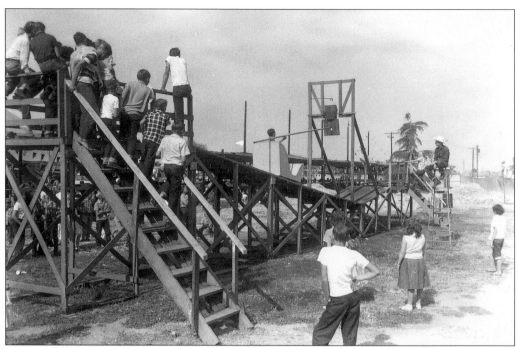

An exciting game at the Dairyland Fair was the "Kuypje Steken." This Dutch game consisted of an inclined platform with a car, a 10-foot pole, and a barrel of water overhead, near the lower end of the incline. Beneath the barrel was a square board with a hole through it.

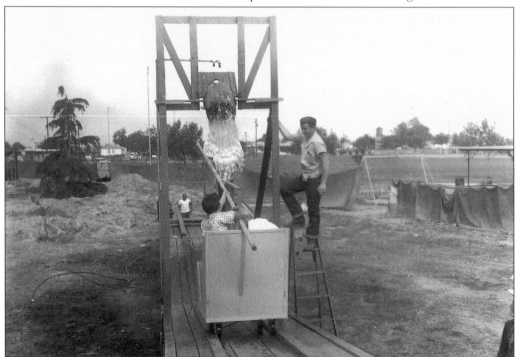

The object of the game was to put the pole through the hole while sitting in the car driving down the incline. If you were unsuccessful, you got drenched with the barrel of water.

Florine Gonsalves (Copeland) was the first
Queen of the Dairyland Fair in 1953.

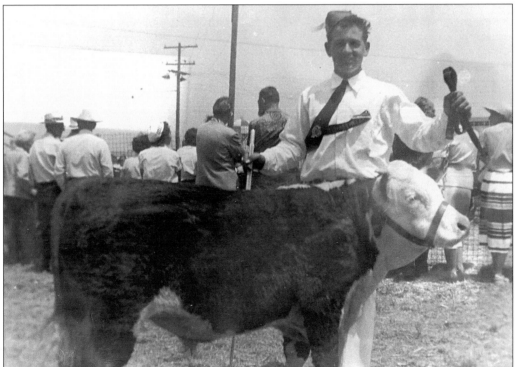

The Artesia Dairyland Fair featured a Junior Livestock Show. George Borden, a member of 4-H, proudly displays his prize-winning Hereford steer. The quality of the livestock show was so well known that on request of commercial breeders, an open division was added. The finest commercial herds were then exhibited. (Photo courtesy of Myrt Franz.)

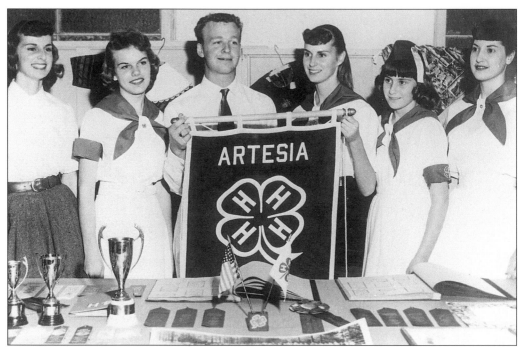

Committed members of the Artesia 4-H Club are pictured from left to right as follows: Martha DeLeenheer, Shannon Hamm, Elbert "Sonny" Borden Jr., Mary DeLeenheer, Shana Houston, and Jackie Lopes. Elbert and Myrt Borden Franz were sponsors of this group for over ten years. Myrt also taught cooking and sewing classes to this group. (Photo courtesy of Myrt Franz.)

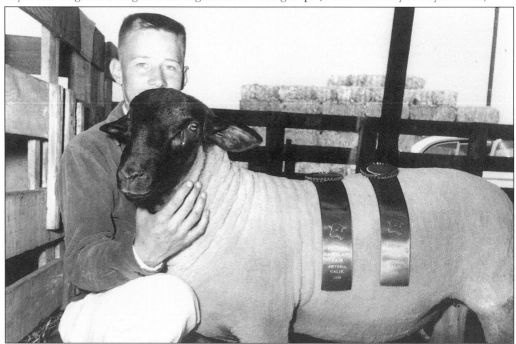

This young man was the proud winner of two blue ribbons at the Artesia Dairyland Fair in 1959.

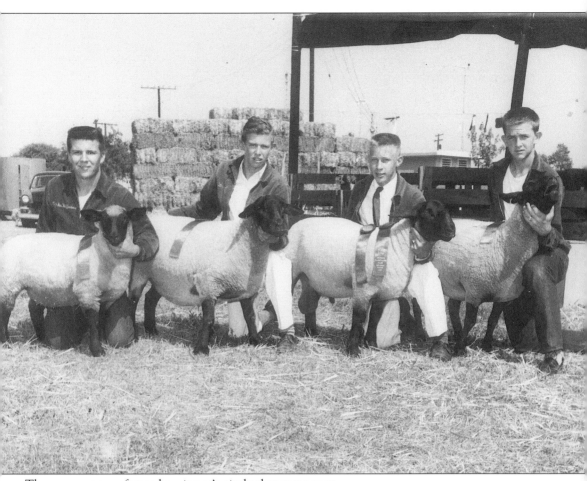

These young men formed a winner's circle that same year.

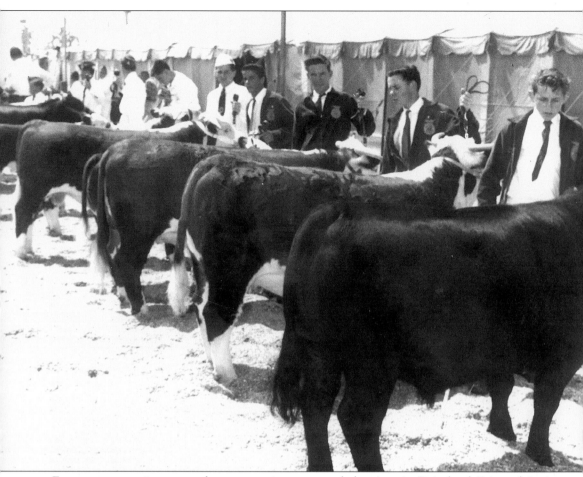

For ten consecutive years, the community sponsored the Artesia Dairyland Fair and Junior Livestock Show through the Artesia Chamber of Commerce. Eighteen hundred boys and girls of 4-H and Future Farmers of America participated and showed their livestock. The total number of boys and girls who benefited from this event is unknown because each of the above mentioned boys and girls had brothers, sisters, cousins, and friends who were influenced by the industrious integrity and honesty of these fine young people.

## *Eight*
# FLOODS, FLOWERS, AND FOOD

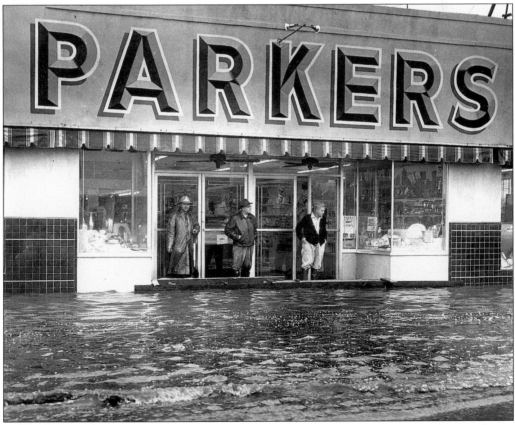

In January of 1952, torrential rains hit Southern California. Streets, homes, and many dairies were flooded. The community had to band together to overcome the damaging effects.

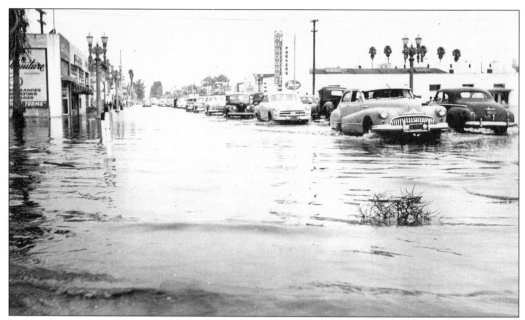

Clogged drains at the railroad tracks and the Norwalk runoff caused rising tides and kept motorists high on the road crown for days. Local newspaperman George Wright was quoted as saying, "Flooding was expected. Water would run in the front door and out the back. We used to keep a pair of hip boots so we could go to the bank on Pioneer Boulevard. They used to take rowboats down that street."

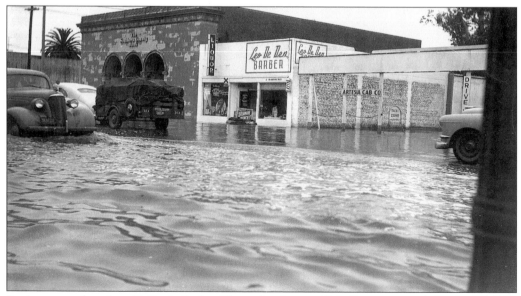

Businesses such as Leo DeDen's Barber Shop, the Artesia Cab Company, and the former First National Bank on Pioneer Boulevard were closed until the floods subsided.

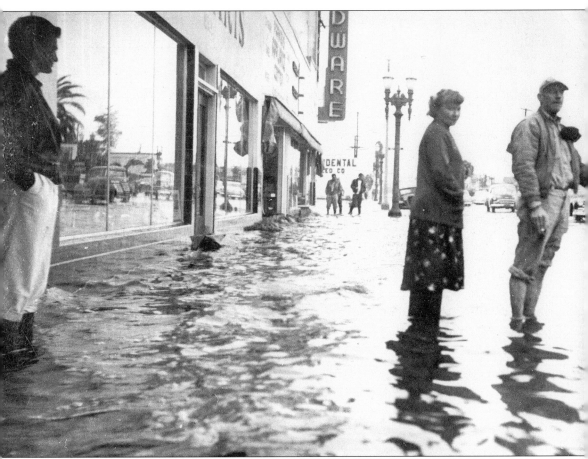

Artesians stared in disbelief at the water covering their community. During the floods, evacuees took shelter in the Pioneer School, the Methodist Church, the Christian Church, and the Woman's Clubhouse. As a result of this experience, Artesians lobbied Los Angeles County Supervisor Frank Bonelli for storm drains, and the Los Angeles County Artesia-Norwalk Storm Drain System was installed thereafter.

"Queen Juliana of the Netherlands with her appealing warmth and vitality received the tribute of her fellow countrymen and Artesian residents on her tour here . . . She and husband Prince Bernhard visited the Ted Bouma Dairy at 11438 East 195th Street, as well as visiting the residents of the Christian Home for the Aged, 11614 East 183rd Street where the Queen joined in with the happy throng in singing the Dutch national anthem." (*Artesia News*, Friday, April 25, 1952.) In this photo, Queen Juliana leads the line of dignitaries walking to the Bouma Dairy Barn. Following her are Mrs. Bouma, Prince Bernhard, and Mr. Bouma. (Photo courtesy of Alice Bouma.)

Mrs. Bouma shows Queen Juliana the Bouma Dairy Barn. (Photo courtesy of Alice Bouma.)

The chrysanthemum is the official flower of the city of Artesia. The Chrysanthemum Festival was established in the mid-1950s. It was sponsored by the City of Artesia Department of Parks and Recreation, The Garden Section of the Woman's Club, and the Artesia Chamber of Commerce. This festival was an opportunity for Artesians to showcase their home-grown flowers and create flower arrangements. In 1970, an art show was added to the festival.

To promote the beautification of Artesia, residents were encouraged to grow chrysanthemums in their yards.

Recognition was given for the best residential flower gardens.

# Artesia Bakery

The Lakeman family purchased the Artesia Bakery from Jim Albers in 1952. The bakery features decorated cakes and pastries, 30 varieties of fancy cookies, breads, imported chocolate, and specialties. This symbol of a man blowing a horn is the trademark of the Dutch Bakers' Guild in Holland. Hundreds of years ago, bakers used wood-burning stoves to bake bread. When the bread was ready, they would alert the townspeople by blowing the horn. In Artesia, this symbol is the trademark of the Artesia Dutch Bakery. (Marius Lakeman 1999.)

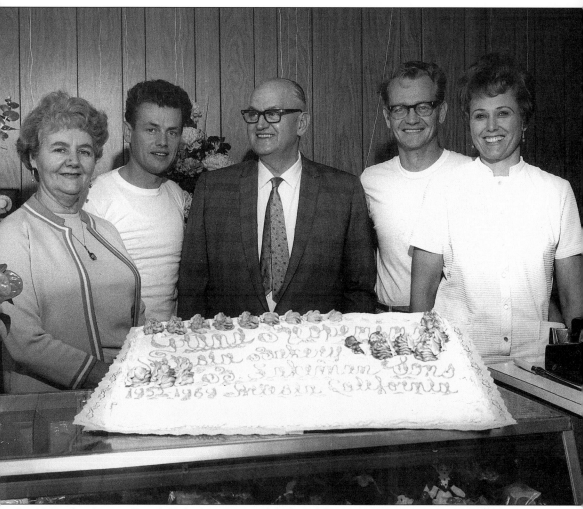

In 1969, the Artesia Dutch Bakery was remodeled. Celebrating the event are as follows, from left to right: Lennie Lakeman, wife of Barend; Fred Lakeman, son; Barend Lakeman, owner; and Marius and Iona Lakeman, son and daughter-in-law.

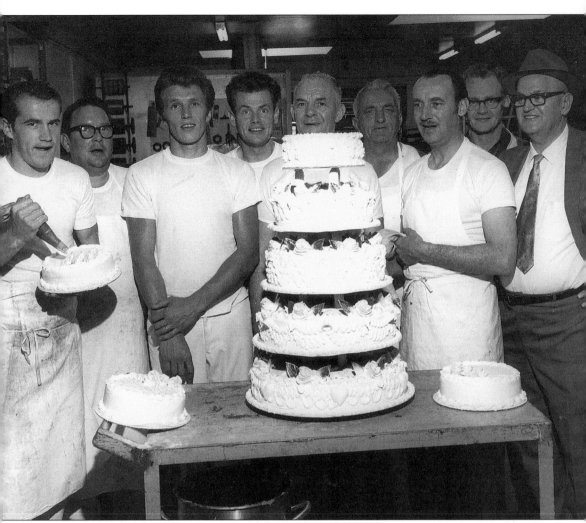

These bakers, all born in Rotterdam, Holland, proudly display the kind of cake that has made the Artesia Dutch Bakery one of the most well-known and well-loved businesses in the area. Pictured from left to right are the following: Matt Vrolyks, Joop Geukens, Leo Hordyk, Fred Lakeman, Wim Visser, Sipke Plat, Pete Visser, Marius Lakeman, and Barend Lakeman, owner.

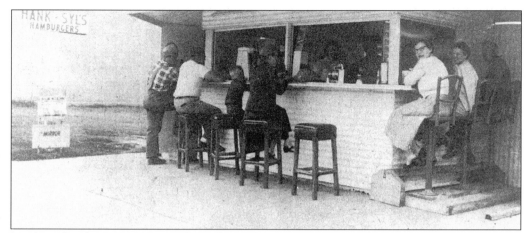

Hank and Syl's Hot Dog Stand was located at 18429 South Pioneer Boulevard. This 1949 picture shows how it all began. Identifiable patrons appear in the threesome on the right: (from left to right) Hank's wife, Bertha Herrema; Frankie (Adamson) Leeanders; and former Postmaster Harry Sumners Sr.

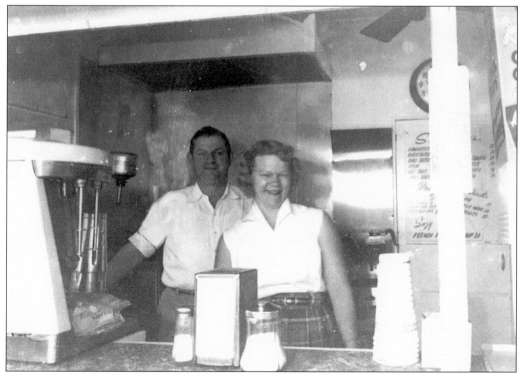

When Dr. Pliny Haskell decided to develop his land in 1955, this hot dog stand was threatened with extinction, but Hank decided to move the business indoors to one of the units in the proposed shopping center. The new venue was named Hank's Coffee Shop and was in business from 1955 to 1985. Pictured here are Hank Herrema and his sister, Syl. (Photo courtesy of Gordon Herrema.)

# MENU

## HANK'S COFFEE SHOP

### OPEN 6:30 A.M. TO 8:00 P.M.
Two or more per booth between 11 a.m. and 2 p.m. and between 5 p.m. and 7 p.m.

**18429 Pioneer Blvd.,**                                              **Artesia, Calif.**

### Phone UN 5-3366
### BREAKFAST-ANYTIME
### COFFEE INCLUDED
### 2 CUPS WITH BREAKFAST

1. HASH BROWNS, TOAST, 2 EGGS ........................................................ .90
2. HAM, BACON, OR SAUSAGE, 2 EGGS, TOAST, HASH BROWNS  1.25
3. 2 EGGS, 2 HOT CAKES ........................................................ .90
4. 1 EGG – 2 HOT CAKES ........................................................ .75
5. HAM, BACON, OR SAUSAGE, 2 HOT CAKES ........................ .95
6. HAM, BACON, OR SAUSAGE, 1 EGG, 2 HOT CAKES ............... 1.05
7. 2 EGGS, TOAST ........................................................ .70

STEAK & EGGS  1.85     CHEESE OMELETTE 1.05     HAM OMELETTE 1.25

### JUICES
TOMATO - ORANGE - GRAPEFRUIT - .20

### SIDE ORDERS

| | | |
|---|---|---|
| COLD CEREAL............ .25 | | SAUSAGE.................. .40 |
| HASH BROWNS........... .25 | TOAST .................. .25 | BACON............... .40 |
| FRENCH  TOAST... | FRENCH FRIES.......... .25 | HAM ..................... .40 |
| 2 SLICES........ .45 | 2 EGGS.................... .30 | 2 HOT CAKES............ .40 |
| 3 SLICES....... .60 | | 3 HOT CAKES............ .55 |

The coffee shop menu included many things that were not possible to serve at the stand. Breakfasts and a substantial sandwich listing were added to the hot dogs, hamburgers, and malts. (Photo courtesy of Gordon Herrema.)

# *Lunches*

DINNER STEAK, (8 OZ. SPENCER) HASH BROWNS, SALAD, COFFEE  $1.75
HAMBURGER STEAK HASH BROWNS, SALAD, COFFEE ...... $1.25
CHILI SIZE .80

## SANDWICHES

| | | | |
|---|---|---|---|
| HAM & CHEESE...................... .60 | BACON & TOMATO.............. .50 |
| PASTRAMI.............................. .60 | TUNA SALAD...................... .50 |
| PATTY MELT........................ .70 | EGG & CHEESE................... .40 |
| HAM.................................... .55 | HAMBURGER...................... .45 |
| BACON & CHEESE................. .55 | CHILI DOG........................ .35 |
| BACON & EGG...................... .60 | GRILLED CHEESE.............. .35 |
| HAM & EGG.......................... .60 | LETTUCE & TOMATO.......... .45 |
| CHEESEBURGER................. .50 | FRIED EGG........................ .35 |
| CHILIBURGER.................... .50 | HOT DOG.......................... .30 |

STEAK SANDWICH (with salad).... 1.00

### CAMPBELLS SOUPS .25
CHILI BEANS.. .40

## SALADS

COLD FRUIT......... .35        LETTUCE & TOMATO... .30        CHEF'S SALAD........... .75

## DESSERTS

PIE... .25        PIE ALAMODE... .35        DONUTS... .10        COFFEE ROLL... .20

COOKIES..3 for .10        SUNDAES... .35        ICE CREAM... .10

## DRINKS

COFFEE .15        TEA .15        ICED TEA .15

MILK .15        BUTTERMILK .15        CHOCOLATE MILK .15

HOT CHOCOLATE .15        POP .10        7 UP .15

ICE CREAM SODA .35        MALTS & SHAKES .40

T - BIRD .20        LEMONADE .15

One distinctive feature of the lunch menu was Hank's famous "curly fries." On Monday, April 1, 1974, 25 years after his business began, Hank served up his 1.3 millionth hamburger. This coffee shop was one of the most beloved dining spots in Artesia. (Photo courtesy of Gordon Herrema.)

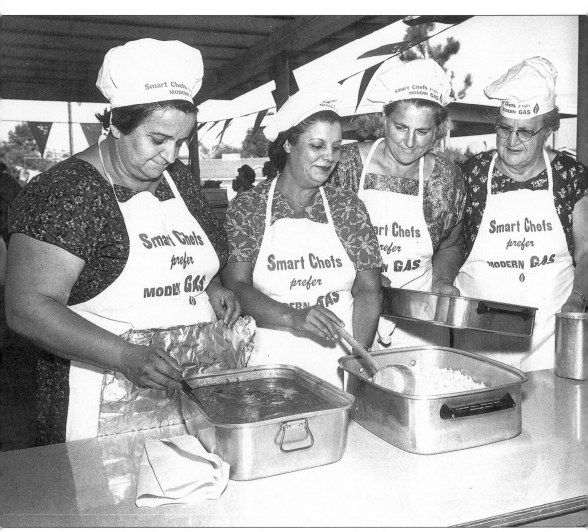

Artesia residents have long known the importance of celebrating community life together. These women are preparing food for one of the many city barbeques.

# Nine

# FROM TOWN TO CITY

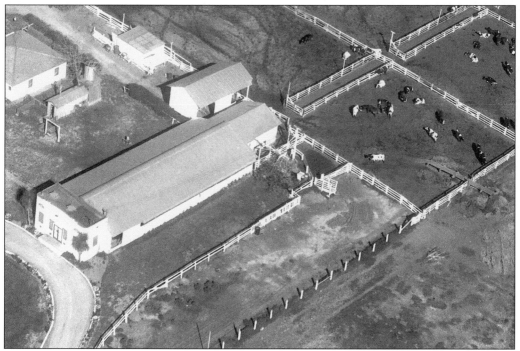

The pressure of growth of the surrounding areas and the desire for expansion posed a problem for the agricultural community. To meet this problem, the city of Dairy Valley was incorporated on April 24, 1956. The new city was shaped like a horseshoe around Artesia, with the prongs facing north into Norwalk. A portion of the original Artesia town site on the south was cut off by the new boundaries. In 1964, this small area was annexed to Lakewood.

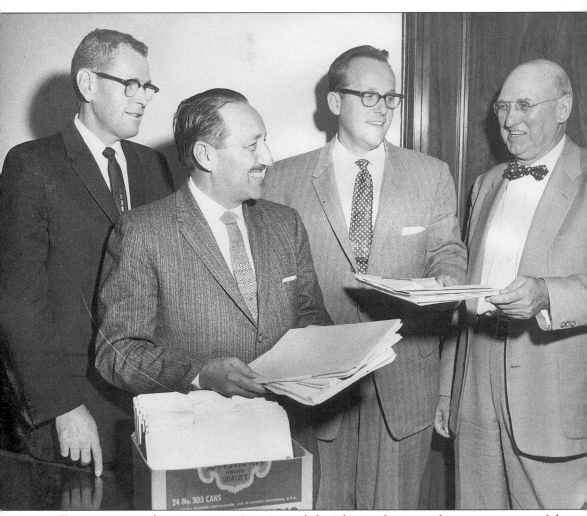

To maintain good civic services, Artesia was left with two choices: either annex to one of the adjoining cities or establish a city within the remaining area. On September 2, 1958, the Artesia Chamber of Commerce endorsed incorporation for Artesia. On May 29, 1959, the City of Artesia was incorporated, with an area of 1.6 square miles and a population of approximately 10,000 people. George Sutton, Supervisor Frank G. Bonelli, unidentified, and Al Little, pictured from left to right, review the petitions for incorporation.

**FRANK G. BONELLI**
SUPERVISOR FIRST DISTRICT

# County of Los Angeles
## Board of Supervisors
### 501 Hall of Records
### Los Angeles 12
### Madison 8-9211

MEMBERS of the BOARD
BURTON W. CHACE
CHAIRMAN
FRANK G. BONELLI
KENNETH HAHN
JOHN ANSON FORD
WARREN M. DORN

November 18, 1958

Mr. Al Little, Secretary-Manager
Artesia Chamber of Commerce
18632 1/2 South Pioneer Boulevard
Artesia, California

Dear Al:

It was indeed a great pleasure to be present with you on Monday afternoon when the petitions calling for an election on the proposed incorporation of Artesia were filed with the clerk of the Board of Supervisors.

As you recall, a photograph of the occasion was taken by Harry Laugharn Jr. I thought you might appreciate a copy of this picture to keep as a memento of the event. It was nice seeing you again.

With kindest personal regards.

Cordially,

Frank G. Bonelli
Supervisor, First District

FGB:cr

Enclosure

This letter from Frank G. Bonelli, supervisor of the First District, Los Angeles Board of Supervisors, acknowledges the receipts of petitions requesting incorporation.

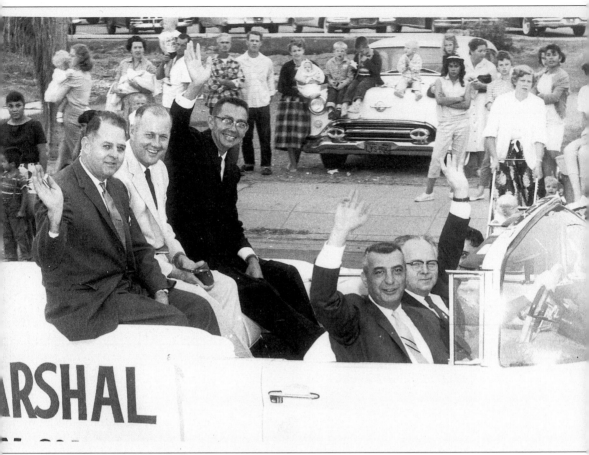

The first city council was elected in May of 1959: Paul Parker, mayor pro tem; Fred Troost, council member; W.E. "Gene" Padelford, mayor; Dave Seldeen, council member; and Eugene Donahue, council member. This photo was taken when they were the grand marshalls of the Artesia Dairyland Fair that same year.

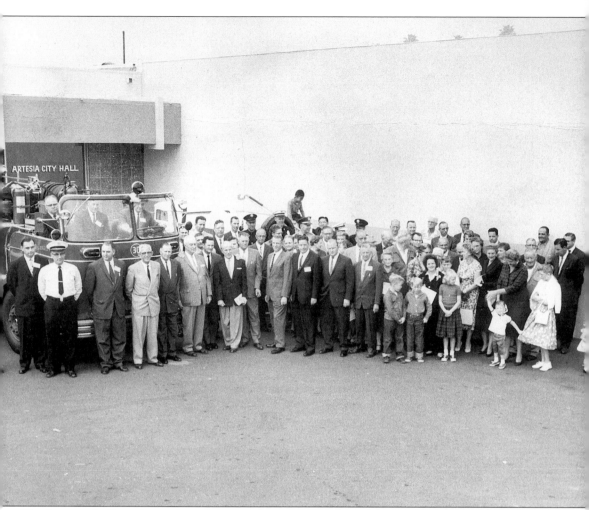

The first city hall was located at 18413 South Pioneer Boulevard from 1959 to 1966.

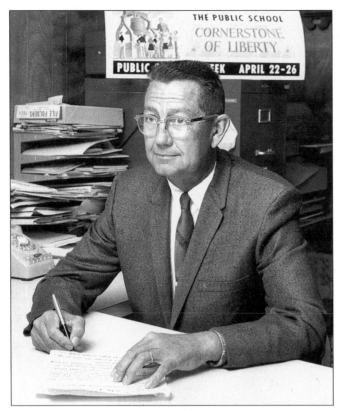

Gene Padelford, first mayor of Artesia (1959–1961), owned A.J. Padelford and Son Construction Company with his father. He served as mayor again from 1966 to 1968 and 1973 to 1974. He was the Chamber's Man of the Year in 1965.

In 1966, the city hall moved its location to the administrative offices of the Clifton School, located at 11729 183rd Street.

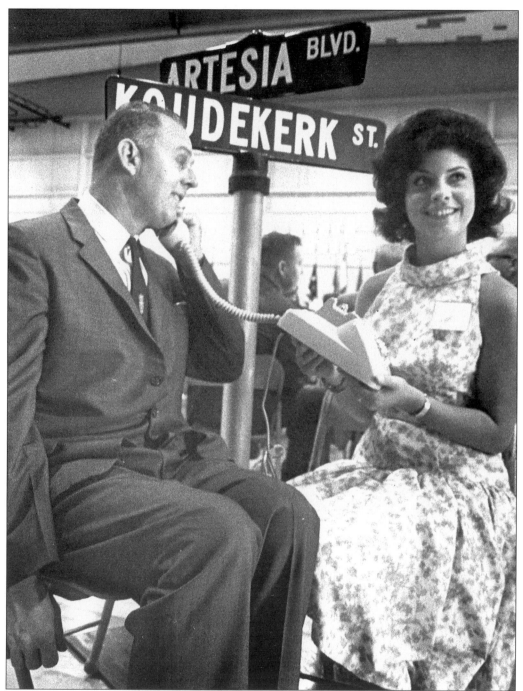

On October 24, 1960, Artesia became the sister city to Koudekerk aan den Rijn, the Netherlands. Koudekerk named a street after Artesia, and Artesia named a street after Koudekerk. At the time, the sister city relationship began, the two cities were about the same size and had similar agricultural and industrial developments. Mayor Paul S. Parker and Stanny Van Baer, Miss International of 1962, portrayed a simulated call to Mayor Waverijn of Koudekerk.

On July 26, 1962, officials and guests from Artesia and surrounding communities observed the impressive ceremony that connected the Telstar Satellite telephone call from Artesia High School to Koudekerk, Holland, our sister city. Artesia was the only city in Southern California to be chosen by the United States Information Agency to talk with its sister city. This was the first sister city satellite phone call ever made.

Council member Fred Troost, chairman of the Sister City Committee, talks with Mayor Waverijn of Koudekerk via the Telstar satellite system. Mayor Paul Parker is to his left, and council member Dave Seldeen is to his right.

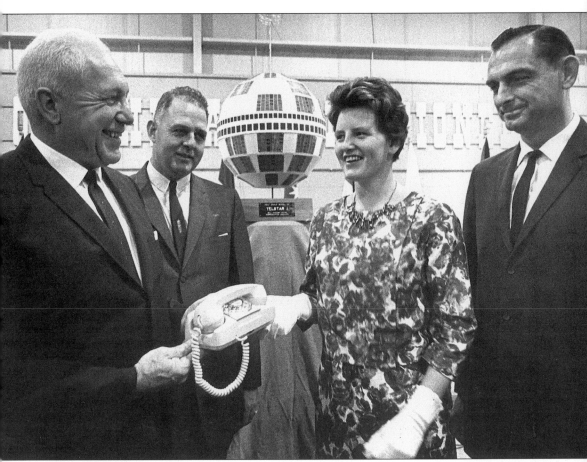

Mr. C.R. "Chet" Baldwin (pictured extreme left), Southern Area Public Relations Administrator for GTE California, presents Mrs. John Bos with a Starlite Telephone. Looking on are Mayor Paul S. Parker (second from left) and Artesia city manager Ed W. Medley (extreme right). Mrs. Bos visited Koudekerk and displayed this phone at the Koudekerk City Hall. It was then brought back to Artesia, where it was suitably inscribed and displayed at the Artesia City Hall.

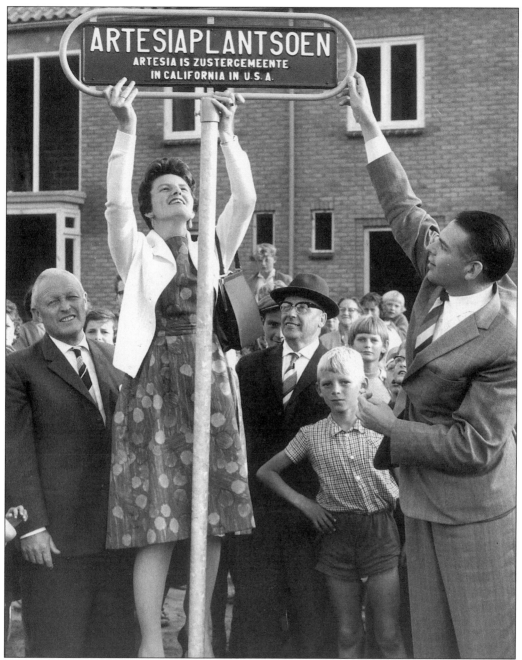

On August 7, 1962, Mrs. John Bos (center); Mayor Waverijn (right); Mr. W. Van Vighen, Alderman (center); and Mr. G.T. Corts, city clerk, placed a sign that read "Artesia Plantsoen (Artesia is our Sister City in California USA)." Artesia's participation in the Sister City Program was almost by accident. It began when the mayor of Koudekerk wrote Artesia officials a letter requesting their help in making a Dutch family in the process of settling in Artesia "feel at home." Correspondence developed between the two cities, and they began the process of becoming sister cities. In April 1960, Alice and John Bos came to Artesia from Koudekerk. Mr. Bos became a milker for the Bass Van Dam Dairy.

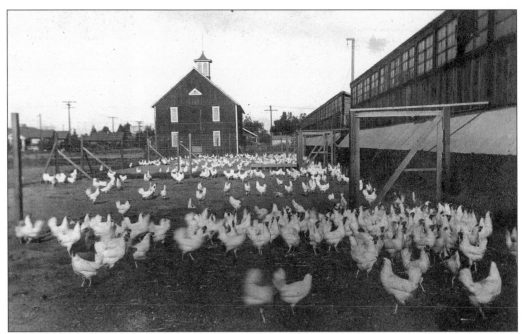

This 16-acre chicken ranch, located at the corner of Clarkdale and South Street and pictured here in 1928, was operated by Art and Albert Frampton. It became the Artesia County Park in 1951.

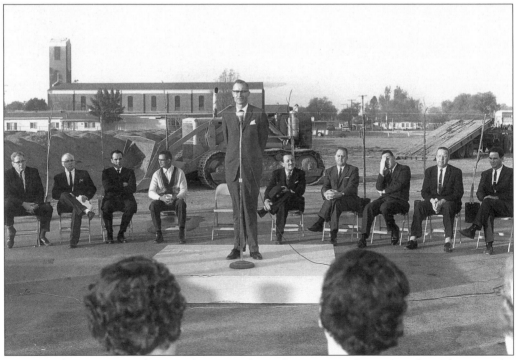

In 1960, the Artesia Park was taken over from the county of Los Angeles. This was the dedication ceremony of Artesia's first city-owned park.

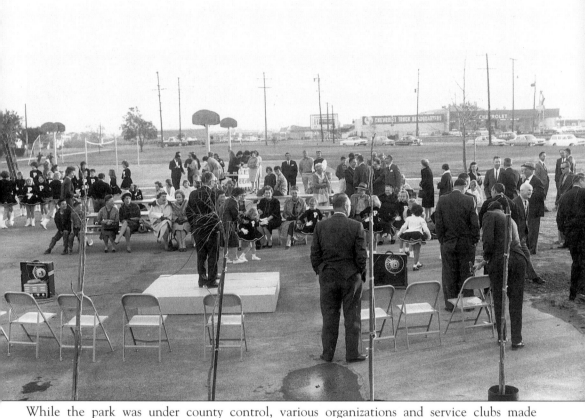

While the park was under county control, various organizations and service clubs made improvements to the park site. Holy Family Church provided the basketball hoops and backboards, the Chamber of Commerce provided night lighted softball facilities, and the Artesia Lions Club donated the picnic shelter, barbecue pit, and lighting equipment.

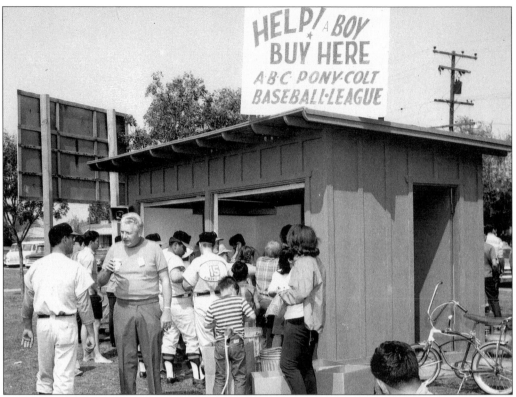

Supporters of the ABC Pony Colt Baseball League gather at the park's refreshment stand.

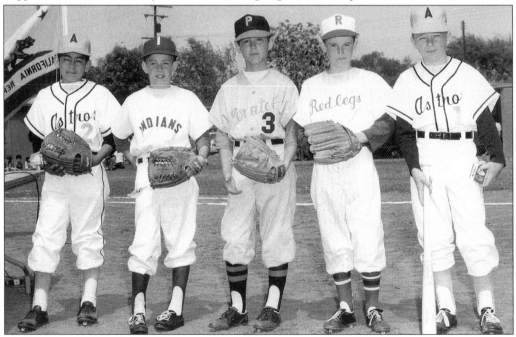

Representatives from the Little League teams—the Astros, the Indians, the Pirates, and the Red Legs—are ready to play ball.

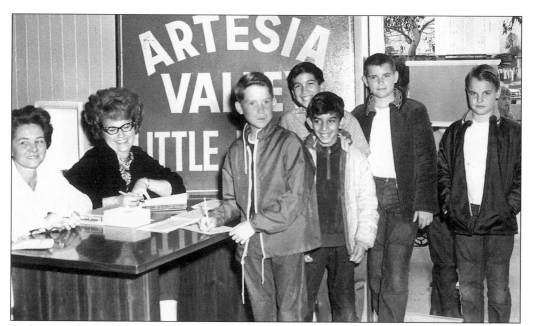

Enthusiastic boys sign up for the Artesia Valley Little League.

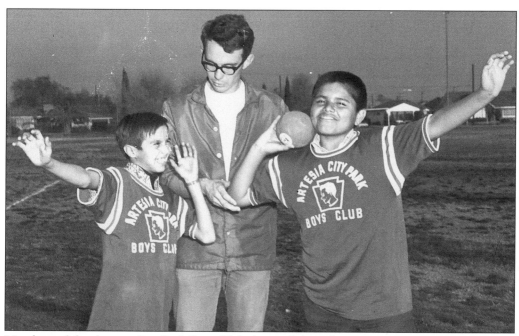

Members of the Artesia City Park Boys Club show off their shot put moves.

Participants in the park's Huck Finn Days activities sported their best hats and cut-off pants.

Members of the Artesia Park Women's Basketball Team posed with Marguerite Phares, parks and recreation director.

A Bluebird Troop, with their leaders, Mrs. June Lawson and Mrs. Ethel Lee, prepare to plant trees in the Artesia Park.

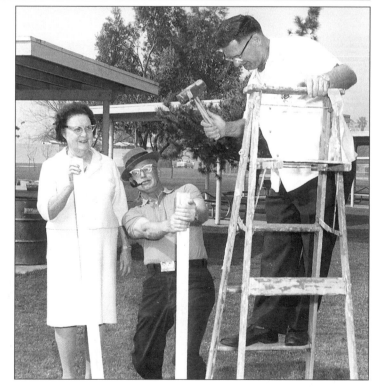

Maude West, garden section chairperson of the Artesia Women's Club; Gene Coats, Artesia Chamber of Commerce manager; and Andy Anderson, member of the Beautification Committee and the City Parks and Recreation Commission, celebrated Arbor Day at the Artesia Park on March 9, 1968.

The Artesia Library, the 13th branch of the Los Angeles County Free Library System, was established in June 1913 through the efforts of C.L. Edgerton, principal of the Artesia Grammar School. The 1914 City Directory lists the library at Main Street and 4th (Pioneer and 186th Street). Mrs. Della M. Brooker was in charge. She served the library until her retirement in 1934. The library began with a collection of 50 books.

In 1963, a new 5,151-square-foot building was completed at the Artesia Park, located at 18722 South Clarkdale Avenue. This branch of the Los Angeles County Library shared the new building with the Parks and Recreation Center. The library had 21,000 volumes, 85 magazine and newspaper subscriptions, 311 record albums, and 356 record singles. Circulation was 33,5000 books a year.

Miss Janet Anderson, long-time Artesia librarian, approaches the reference desk. Another long-time community volunteer was Martha Mandel, who devoted many hours of her time on behalf of the library and the larger community.

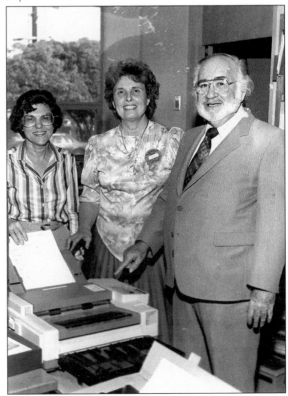

Pictured from left to right are the following: Marian Gasser, librarian; Lorraine Zuniga, Friends of the Artesia Library; and council member, James Van Horn. They are showing off a new piece of library equipment.

Young readers of all ages enjoy the books available in the children's section of the library.

Like the Artesia Library, the Artesia Post Office has had many locations throughout the city, including that of the first store in 1882, the Scott and Frampton Building, and the building pictured here at 18413 South Pioneer Boulevard.

In 1969, groundbreaking ceremonies were held for the new post office located at 11721 183rd Street. Present for the ceremonies were the following (from left to right): Gordon Herrema, council member; Tony Cordeiro, mayor of Cerritos; Dr. Walter T. Mullikin, council member; Gene Padelford, council member; Henry Dirksen, council member; and Paul Smith, Artesia mayor. Smith negotiated with the ABC School Board for the purchase of the vacant Clifton Elementary School pictured here, which was removed for the construction of the new post office.

# *Artesia* NEWS

## Only Adjudicated Legal Newspaper Published in Artesia

The *Artesia News* was Artesia's only adjudicated, legal newspaper. Owned and operated by George and Lucille Wright from 1944 to 1975, its advertisement boasted that it was the only newspaper "printed and published in Artesia." The coverage area was from Alondra Boulevard south to the county line and from the San Gabriel River east to Coyote Creek. The newspaper was printed on Thursdays. If you lived south of 186th street, the paper was delivered on Fridays. If you lived to the north, you received it the following Monday. Besides the Wrights, the staff included Bill Kerally; Dian Morris, social editor for 22 years; and Mrs. Shirley Collins, the Wright's daughter.

*Artesia News* publishers George and Lucille Wright talk with assembly member Joe A. Gonsalves, representative for the 66th District from 1963 to 1975.

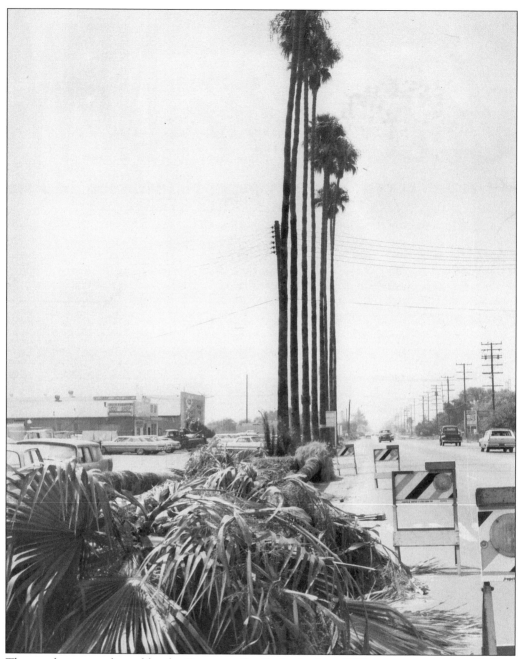

These palm trees, planted by the Frampton family in the late 1800s, were removed in 1967 to make way for the widening of Pioneer Boulevard.

# *Ten*
# ANNIVERSARY
# CELEBRATIONS

Freeway construction through Artesia began in 1968. The Artesia Freeway (Route 91) was completed in 1975.

The Santa Ana Freeway was constructed between 1944 and 1958. The San Gabriel River Freeway (Route 605) was built between 1964 and 1971.

# Save Artesia's Very Existence

## VOTE NO ON CONSOLIDATION

### TUES., MAY 11, 1971

CITIZENS FOR ARTESIA

At the time, it seemed to some that the merging of Artesia and Cerritos would be a logical move, therefore talk of consolidation began. Community meetings were held, but when the vote was taken, 1,362 Artesians voted "no" on consolidation, and 1,140 voted "yes." Thus, Artesia would remain its own city.

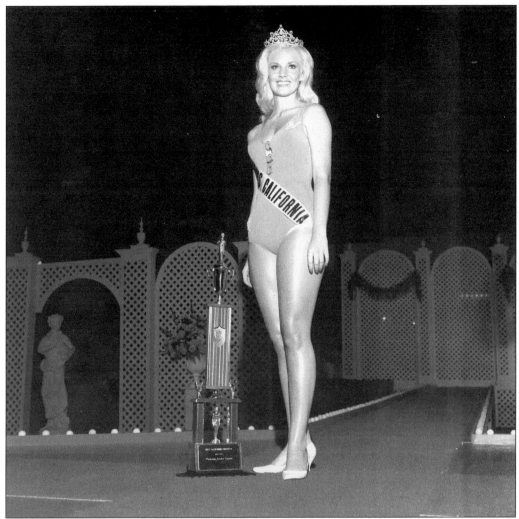

Carol Herrema, Miss Artesia 1972, was born in Artesia and educated locally. The daughter of John and Florence Herrema, she reigned as Miss California from 1972 to 1973. All the citizens of Artesia were honored to have Carol represent the city and California in the Miss USA-Miss Universe Beauty Pageant.

The A.J. Padelford Park, developed in 1973, is located at 16912 Clarkdale Avenue. It was named after a long-time Artesia resident, businessman, and civic leader. Mr. Padelford was president of the Artesia Chamber of Commerce and the Lyons Club, as well as a member of the Elks.

Pictured above is the playground area of the A.J. Padelford Park.

The new city hall, located at 18747 Clarkdale Avenue, was dedicated May 3, 1975, the 100th anniversary of the community of Artesia.

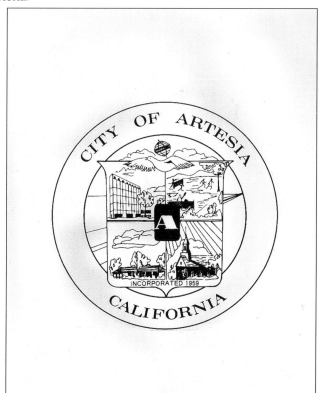

Pictured above is the city seal. Artesia's city motto is "Service Builds Tomorrow's Progress."

In 1962, the Community Center was completed. It houses the Artesia Public Library, a main hall with a stage, a kitchen, and a separate area for meetings.

In 1979, approximately 10,000 square feet were added for additional recreational needs. This new addition contains the park office, kitchen, and additional meeting rooms. It was dedicated on December 15, 1979.

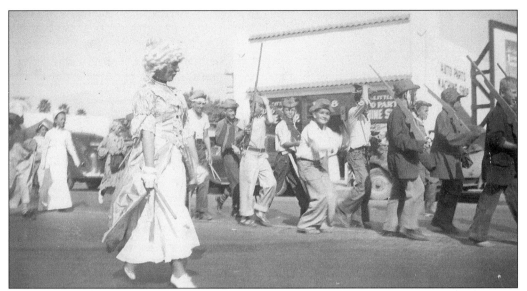

Parades have always been an important part of community life. Artesians gathered here in 1933 to watch the Autumn Festival Parade.

Decades later, enthusiastic residents continue to line Pioneer Boulevard to enjoy the Pioneer Days Activities. Three clowns entertain the crowds as a high school band approaches.

125

Council members are from left to right as follows: Robert Jamison, Dennis Fellows, James Van Horn, Ronald Oliver, and Gretchen Whitney. They are presenting this Girl Scout troop with an award of recognition. It was under the direction of this council that Albert O. Little was commissioned to compile a history of Artesia.

# BIBLIOGRAPHY

*Artesia-Cerritos United Methodist Church 105th Anniversary Publication*, 1981.

Artesia Chamber of Commerce. *History of Artesia*, 1960.

*Artesia City Directory*, 1914–1915.

*Artesia Community News*, September 4, 1997.

*Artesia Masonic Lodge History*, 1906–1981.

*Artesia News*, April 26, 1952 and January 20, 1967.

Bean, Lowell J. "Social Organization in Native California." *Native Californians: A Theoretical Retrospective*. California: Romona Press, 1976.

Borah, Woodrow. "The California Mission." *Ethnic Conflict in California History* (C. Wollenberg, ed.). Los Angeles, CA: Tinnon-Brown, Inc., 1970.

Burkhart, E. *100 Years of Christian Church History 1893–1993*, published 1993.

California-Pacific Conference, *United Methodist Church Archives*, School of Theology, Claremont, California.

*Celebration Program of the First Fifty Years of the New Life Community Church, 1982.*

*Community Advocate / Artesia News*, March 27, 1974.

*Community Advocate*, July 31, 1985.

Cook, Sherburne F. *The Conflict Between the California Indian and White Civilization*. CA: Unversity of California Press, Berkley.

Friend, Dick. *Personal Narrative*, 1999.

Gonsalves, Jack. *Personal Narrative*, 1999.

Harish, C.P. 1974. *Southern California Water Company History, 1928–1974.*

*Holy Family Church Dedication Souvenir*, August 22, 1948.

Lakeman, Marius. *Personal Narrative*, 1999.

Lang, Lila, Lela Seeley, and Ester Jenkins. *Look! The History of the ABC Unified School District*, 1983.

Little, Albert O., *Reference Notes.*

Little, Albert O. *The Artesians: How It Began One Hundred Years Ago*, 1975.

Little, Albert O. *The Artesians: Twenty Years of Incorporation*, 1979.

Lopez, Ramona Mendez. *Personal Narrative*, 1999.

Los Angeles County Board of Supervisors. *Minutes*, 1928.

*Los Angeles County History, Vol. 4, 1964.*

*Los Angeles Times*, July 29, 1971.

*Luskey's Artesia Cross City Directory*, May 1963.

Pitt, L. and D. Pitt. *Los Angeles A-Z*. Berkeley: U.C. Press, 1997.

Roberts, Laverne Mathews. *Personal Narrative*, 1999.

# Acknowledgments

This book is dedicated to the memory of Albert O. Little (1899–1987), and to the school children of the ABC Unified School District; may you learn to love this community from those who have gone before you.

I would like to express my appreciation to the memory of the founding President of the Artesia Historical Society, June Lawson. I would also like to thank the members of the Executive Board of the Artesia Historical Society—Barbara Frampton Applebury, Glen Wayne Dantema, Gloria Rojo, and Diane Padelford Young—for their support of this project.

Many thanks to Cecelia and Miguel Oportot, who understand the importance of remembering family and community history. Their work in preserving and restoring historic pictures has been invaluable.

To all those individuals listed below who have shared their family pictures and stories, thank you for keeping the history of Artesia ALIVE!

| | | |
|---|---|---|
| Barbara Baird | Howard Frampton | Romona Mendez Lopez |
| Norene Barlow | Myrtle Borden Franz | LaVerne Roberts Mathews |
| Dora Bell | Jack Gonsalves | Kirk Nakakihara |
| Birdie Bickford | Mabel Gonsalves | Joe Nieto |
| Henry Bloomfield | Hank Gray | Dr. Patricia T. O'Malley |
| Mabel Bloomfield | Susan Greene | Paul Phillips |
| Rose Boer | Hattie Hadewig | Pate Schuh |
| Alice Bouma | Gordon Herrema | Kathy Gonsalves Scott |
| Gale Brandon | Louise Howard | Gus Thompson |
| Josephine Herrema Busman | Claire LaBerge | Kathleen Wallis |
| Ellen Carver | Marius Lakeman | Maude West |
| Danita Eastman | Chris Lopez de Gaines | George Wright |

Lastly I would like to thank the members of my immediate family: my daughter, Veronica Elizabeth, for her editorial skills and commitment to writing a history inclusive of all people, and my husband, Edward, for his proofreading, his attention to details, and his emotional and financial support. We couldn't have done it without each other! (Photo: Miguel Photography.)

Veronica Little Bloomfield
December 8, 1999